VIENNA
architecture & design

Edited by Joachim Fischer
Written by Christian Schönwetter
Concept by Martin Nicholas Kunz

content

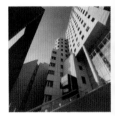

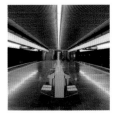

to see . culture & education

to see . public

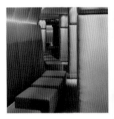

to stay . hotels

to go . eating, drinking, clubbing

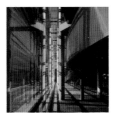

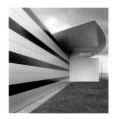

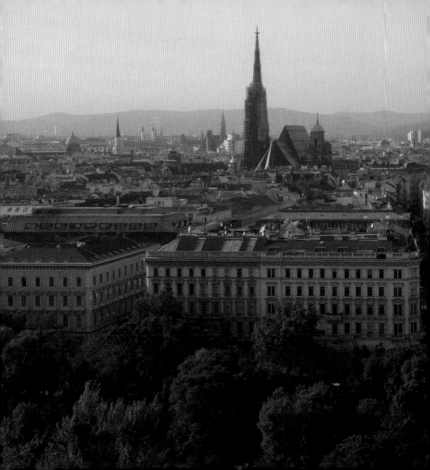

introduction

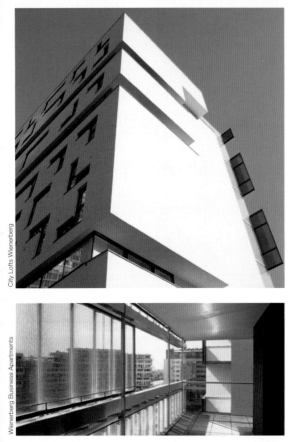

City Lofts Wienerberg

Wienerberg Business Apartments

Nur wenige Großstädte erfreuen sich eines so intakten historischen Stadtbilds wie Wien – ein Umfeld, in dem es nicht unbedingt einfach ist, moderne Architektur zu verwirklichen. Am leichtesten ist dies in den neuen Quartieren Donaucity und Wienerberg, die ausschließlich von zeitgenössischer Baukunst geprägt sind. Die unlängst errichteten Hochhäuser verändern die Skyline der Stadt in einem Maße wie nie zuvor. Im Zentrum jedoch hat sich wegen des hohen Altbaubestands eine besondere Kultur des Aus- und Umbauens entwickelt. Dieser Band zeigt daher nicht nur reine Neubauten, sondern auch zahlreiche Projekte, bei denen aktuelle Innenarchitektur die Hauptrolle spielt.

01. Spittelauer Lände
Zaha Hadid Architects

2005
Spittelauer Lände
9. Bezirk

www.zaha-hadid.com

Few major cities enjoy an historic old center that is as unspoiled as in the heart of Vienna. In these surroundings, it is not exactly easy to plan modern architecture, which works the best in the city's new districts, like the Danube City and Wienerberg quarters. They are exclusively devoted to contemporary architectural design. The skyscrapers that were recently built are changing the city's skyline as never before—and not always for the best. In the center, however, a particular style of redevelopment and reconstruction has emerged due to the high proportion of listed buildings. For this reason, in this category of buildings, there are not only entirely new structures, but also numerous projects for which contemporary interior architecture plays a leading role.

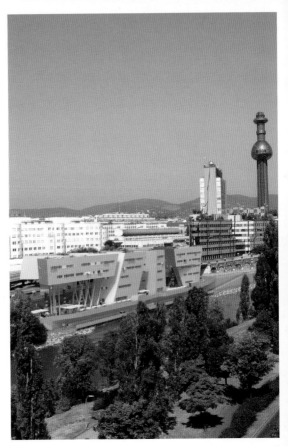

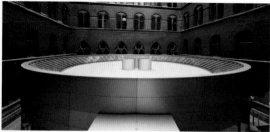

Peu de grandes villes jouissent d'une architecture historique restée aussi intacte que celle qu'on trouve à Vienne et ce n'est pas un contexte où il est simple d'intégrer une architecture moderne. C'est dans les nouveaux quartiers de Donau-city et Wienerberg, caractérisés essentiellement par une architecture contemporaine, que cela semble le plus facile. Les hauts bâtiments construits récemment modifient la ligne d'horizon de la ville dans des proportions jamais atteintes auparavant, et ceci de façon pas toujours avantageuse. Cependant, il s'est développé dans le centre, en raison du nombre important d'immeubles anciens, une culture particulière de l'agrandissement et de la transformation de bâtiments. C'est pourquoi ce volume présente non seulement des constructions nouvelles mais aussi de nombreux projets, dans lesquels l'architecture intérieure actuelle joue un rôle primordial.

Wimbergergasse

Büropavillon im Wiener Rathaus

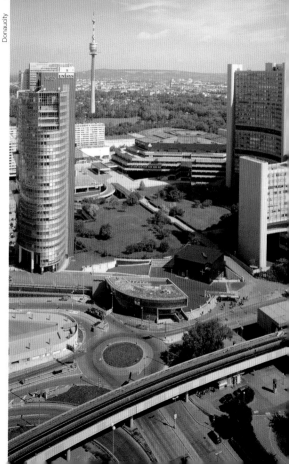

Hay pocas grandes ciudades que gocen de una imagen urbana histórica tan intacta como Viena, un entorno en el que realizar una arquitectura moderna no es necesariamente sencillo. Lo más fácil es hacerlo en los nuevos barrios de Donaucity y Wienerberg que están caracterizados exclusivamente por la arquitectura contemporánea. Los rascacielos erigidos recientemente modifican el skyline de la ciudad en un grado como nunca antes, y no siempre a su favor. No obstante, en el centro se ha desarrollado una especial cultura de la ampliación y la reforma debido a la gran existencia de edificios antiguos. Por eso, este volumen no muestra únicamente puros edificios nuevos, sino también numerosos proyectos en los que la arquitectura actual de interiores juega el papel principal.

to see . living
office
culture & education
public

 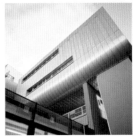

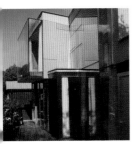 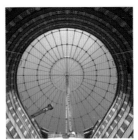 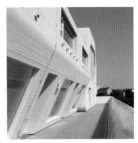

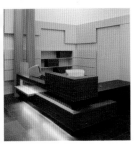 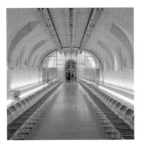 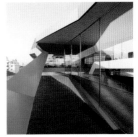

Siccardsburggasse

Patricia Zacek Architektin

2003
Siccardsburggasse 72-74
10. Bezirk

www.patricia-zacek.at

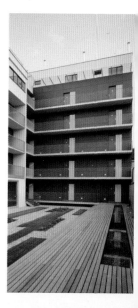

Eine Blockecke mit sorgsam geplanten halböffentlichen Zonen: Der Hof zeichnet sich durch seine strenge, grafisch aufgefasste Gartengestaltung aus, die sauber detaillierten Treppenhäuser durch dunklen Steinboden und grellgrüne Decken. Die Räume in den Wohnungen bieten die Möglichkeit eines Rundgangs.

A corner block of buildings, with carefully planned zones, which are semi-public areas: the courtyard is distinguished by a strict, graphical pattern in the garden area, with clear details on stairwells, marked by dark stone floors and brilliant, bright-green ceilings. There is the option of walking around the rooms inside the apartments.

Un immeuble d'angle dont les espaces semi-publics ont été conçus avec soin : la cour se distingue par l'aménagement rigoureux et graphique du jardin et l'attention portée aux détails des cages d'escalier avec des sols en pierre foncés et des plafonds vert vif. La disposition des pièces des appartements permet de faire le tour en passant de l'une à l'autre.

Una esquina de bloques con zonas semipúblicas cuidadosamente planeadas: El patio se caracteriza por la rigurosa configuración de su jardín, concebida gráficamente, las escaleras detalladas finamente por medio de un suelo de piedra y techos verde chillón. Las habitaciones en las viviendas ofrecen la posibilidad de dar una vuelta.

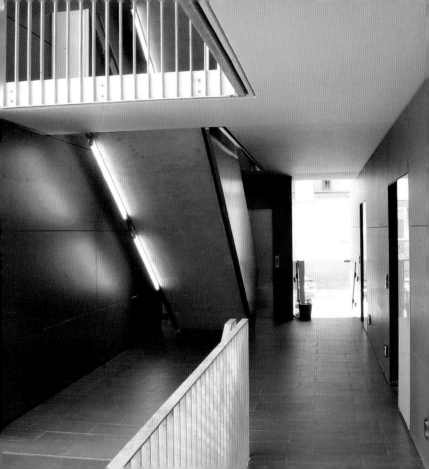

Aspern an der Sonne

Architekt Georg W. Reinberg
Helmut Lutz (SE)

2000
Müllnermaisgasse /
Wulzendorferstraße
22. Bezirk

www.reinberg.net

Die Siedlung wurde konsequent nach der Sonne ausgerichtet, indem die Gebäude so angeordnet wurden, dass sie sich nicht gegenseitig verschatten. Eine Photovoltaikanlage soll den Energieverbrauch reduzieren. Die der Nordfassade vorgelagerten Abstellräume gliedern die Laubengänge und dienen als Wärmepuffer.

The estate was deliberately designed to take into account the sun's movement. The buildings were positioned so that they cannot overshadow each other. A solar energy unit is meant to reduce energy consumption. The storage rooms structuring the northern façade's access balconies serve as an extra layer of insulation.

La cité a été construite en fonction du soleil, les bâtiments ont été ainsi agencés de façon à ce qu'aucun ne porte ombre à l'autre. Une installation photovoltaïque permet une réduction de la consommation d'énergie. Les pièces servant de débarras placées devant de la façade nord organisent les balcons communs et forment ainsi un espace tampon isolant.

La zona residencial fue alineada consecuentemente hacia el sol, colocando los edificios de tal forma que no se dieran sombra unos a otros. Una instalación fotovoltaica ha de reducir el consumo de energía. Los cuartos trasteros colocados delante de la fachada norte dividen las arcadas y sirven para amortiguar la calor.

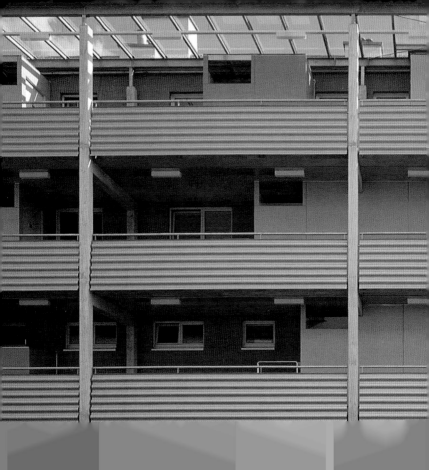

House Ray 1

Delugan Meissl Associated Architects

2003
Mittersteig 10
5. Bezirk

www.deluganmeissl.at

Auf ein Bürogebäude aus den 60er Jahren setzten die Architekten einen Dachgeschossaufbau, der ihre eigene Wohnung beherbergt. Trotz der eigenwilligen dynamischen Formensprache greifen sie dennoch die bandartige Gliederung des bestehenden Baus und die Firstlinien der Nachbargebäude auf.

As the location for their own apartment, the architects planned a roof extension on the top of a 1960s office block. Despite the rather idiosyncratic, dynamic of the form-language, they adopt elements of the existing building's broad shape and the roof's ridging lines of the neighboring building.

Les architectes ont construit sur un immeuble de bureaux des années soixante un étage mansardé où ils ont aménagé leur propre appartement. Bien qu'ils utilisent un langage architectural original et dynamique, ils reprennent cependant l'organisation en forme de bande du bâtiment existant et les lignes de faîtes des constructions voisines.

En un edificio de oficinas de los años 60 los arquitectos colocaron una estructura de ático que aloja su propia vivienda. A pesar del lenguaje de formas dinámico poco convencional retoman la división a modo de bandas de la construcción existente y las líneas de las cumbreras de los edificios vecinos.

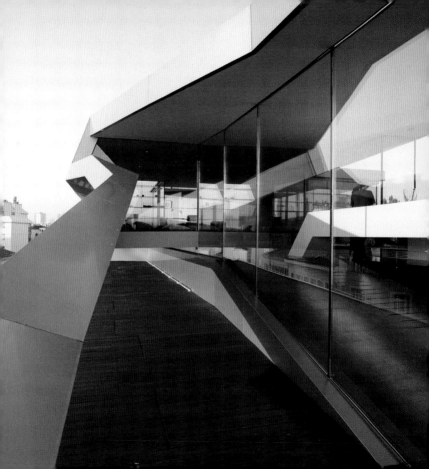

Dachgeschossaufbau

Spitalgasse

Attic Conversion

Heinz Lutter – Büro für Architektur
Fröhlich & Locher Zivilingenieure (SE)

2003
Spitalgasse 25
9. Bezirk

www.arch-lutter.at

Der Dachgeschossaufbau beherbergt zweigeschossige Wohnungen mit Galerieebene. Alle tragenden Wände und Decken bestehen aus vorgefertigten Holzelementen, die in nur 14 Tagen auf dem bestehenden Gebäude zusammengefügt wurden. Die Holzfassade trägt eine Schutzschicht aus hellblauem Polyester.

The attic conversion accommodates two-storey apartments with a gallery level. All load-bearing walls and ceilings are constructed from prefabricated wooden elements added onto the existing building in only 14 days. The wooden façade is treated in a protective coating of light-blue polyester.

La construction sur le toit abrite des appartements à deux étages avec une galerie. Tous les murs porteurs sont constitués de panneaux de bois préfabriqués qui ont été posés en seulement 14 jours sur le bâtiment existant. Une couche de protection en polyester bleu clair recouvre la façade en bois.

La construcción de ático aloja viviendas de dos plantas con un nivel de galería. Todas las paredes y los techos de soporte constan de elementos de madera preconstruidos que fueron montados en el edificio existente en sólo 14 días. La fachada de madera lleva una capa de protección de poliéster azul claro.

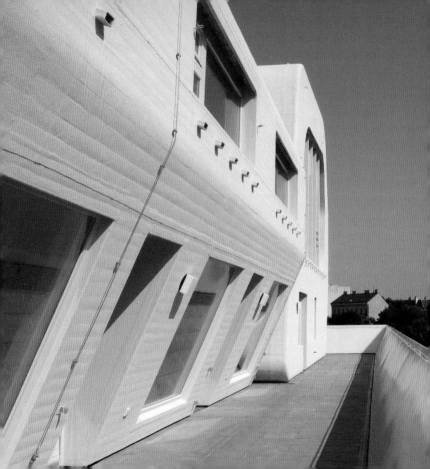

City Lofts Wienerberg

Delugan Meissl Associated Architects

2004
Hertha-Firnberg-Straße 10
10. Bezirk

www.deluganmeissl.at

Während die Wohnräume auf der Südseite 3,30 Meter hoch sind, fallen die Schlafräume auf der Nordseite deutlich niedriger aus. Dadurch entstehen Split-Level-Wohnungen und es bleibt auf der Nordseite noch Platz für mietbare Hobby- oder Büroräume, die sich in der Fassade als verglaste Boxen abzeichnen.

While south-facing rooms are 3.30 meters high, the north-facing bedrooms have considerably lower ceilings. In this way, split-level apartments are created and there is still space on the northern side to lease office or recreational facilities that are visible as glass boxes on the front of the building.

Alors que du coté sud les pièces de vie ont une hauteur de 3,30 mètre, les chambres à coucher du coté nord sont nettement plus basses. Cela forme donc des appartements à paliers et il reste ainsi encore de la place pour des bureaux ou des ateliers pouvant être loués et qui apparaissent en façade comme des cubes en verre.

Mientras que las habitaciones en la parte sur tienen 3,30 metros de altura, los dormitorios en la parte norte son claramente más bajos. Por medio de ello surgen viviendas split-level y en la parte norte todavía queda espacio para cuartos de hobby u oficinas que pueden alquilarse y que se vislumbran en la fachada como cajas acristaladas.

Wienerberg Business Apartments

Cuno Brullmann, Architects
Juvarek & Schweiger (SE)

2004
Hertha-Firnberg-Straße 10
10. Bezirk

www.cunobrullmann.com

Wohnen und Arbeiten unter einem Dach soll dieser Bau ermöglichen. Flexibel kombinierbare Wohn- und Büroeinheiten gruppieren sich um eine Erschließungszone mit Luftraum über mehrere Geschosse in der Gebäudemitte. Wie ein verschiebbarer Vorhang verschatten Wellen aus Aluminiumlochblech die Südfassade.

This complex is meant to provide living and office space under a single roof. Flexible apartment and office units are grouped around an atrium, which ascends several floors at the center of the building. Waves of perforated aluminum cast cladding, like an adjustable curtain, give shade to the southern façade of the building.

Ce bâtiment a été conçu pour permettre d'habiter et de travailler sous un même toit. Des unités d'habitation et de travail, aisément combinables, se regroupent autour d'une zone de circulation qui s'ouvre sur plusieurs étages. Des vagues de plaques d'aluminium perforées forment comme un rideau mobile qui apporte de l'ombre sur la façade sud.

Esta edificación ha de hacer posible vivir y trabajar bajo el mismo techo. Las unidades de oficinas y viviendas que se combinan de forma flexible se agrupan por varios pisos en el centro del edificio entorno a un atrio con espacio de aire. Las ondas de chapas de aluminio perforadas dan sombra a la fachada sur como una cortina corrediza.

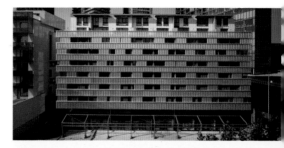

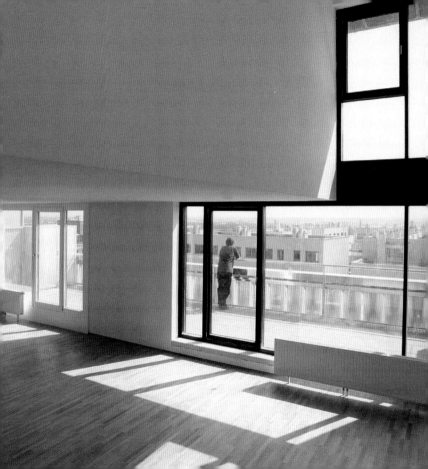

Wohnhaus
Laubeplatz

Prof. Dr. August Sarnitz
Zemler & Raunicher, Eva Schlegel (SE)

2004
Laubeplatz 3
10. Bezirk

www.wbv-gpa.at
www.sarnitz.at

Verglaste Loggien und verglaste Wintergärten bilden ein Kunstwerk aus Glas und Spiegeln. Das Kunstspiel reflektiert den unterschiedlichen Grad der Öffentlichkeit/Privatheit der Loggien und Wintergärten: zum öffentlichen Park reflektierend (Spiegelglas) zum Gartenhof schützend und transparent (Klarglas und Spiegelglas).

Glazed loggias and winter gardens create an artwork of glass and mirrors. The art-play reflects the different degree of public/private space of the loggias and winter gardens: reflecting towards the public park (mirrored glass) and protecting and transparent towards the garden courtyard (clear glass and mirrored glass).

Des loggias et des jardins d'hiver forment une œuvre d'art en verre et glace polie. Ce jeu artistique reflète la différence entre le domaine public/privé des loggias et des jardins d'hiver : le côté parc public réfléchit la lumière (glace polie) et le côté cour-jardin offre protection et transparence (verre et glace polie).

Logias e invernaderos acristalados forman una obra de arte hecha de vidrio y espejos. El juego artístico refleja el distinto grado público/privado de las logias y los invernaderos: reflectante hacia el parque público (cristal de espejo), protector y transparente hacia el patio ajardinado (vidrio claro y cristal de espejo).

Gasometer

Jean Nouvel, Coop Himmelb(l)au,
Manfred Wehdorn, Wilhelm Holzbauer

2001
Guglgasse 8-14
11. Bezirk

www.wiener-gasometer.at

Vor den Toren der Stadt hat sich ein altes Industriebauwerk in eine moderne Shopping-Mall mit darüber liegenden Wohnungen verwandelt. Die beteiligten Architekturbüros fanden je völlig unterschiedliche Lösungen, um in den vier schwer zu belichtenden ehemaligen Gaskesselgehäusen Wohnungen unterzubringen.

At the city gates, an old, industrial site has been transformed into a modern shopping mall with apartments located above it. Each of the architects' studios involved in the project found quite different solutions for accommodating new apartments on the site of four, former gasometer buildings that are difficult to provide lighting for.

Aux portes de la ville un ancien bâtiment industriel a été transformé en une galerie marchande moderne avec des appartements au-dessus. Les architectes, qui ont participé au projet, ont trouvé chacun des solutions totalement différentes pour aménager des appartements dans les quatre anciens gazomètres, dans lesquels il était difficile de résoudre le problème de l'éclairage.

Un antigua edificación industrial ante las puertas de la ciudad se ha transformado en un shopping-mall moderno con viviendas situadas sobre ella. Las oficinas de arquitectos participantes encontraron respectivamente soluciones completamente diferentes para alojar viviendas en las cuatro carcasas de las calderas de gas difíciles de iluminar.

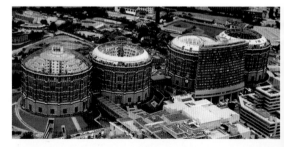

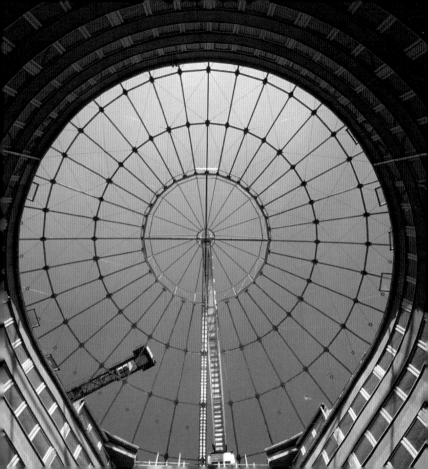

Gasometer A
Jean Nouvel
www.jeannouvel.com

Gasometer B
Coop Himmelb(l)au
www.coop-himmelblau.at

Gasometer C
Manfred Wehdorn
www.wehdorn.at

Gasometer D
Wilhelm Holzbauer
www.holzbauer.com

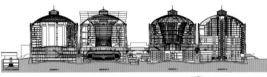

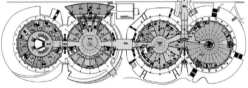

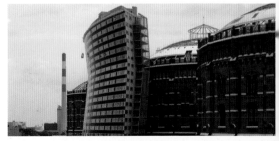

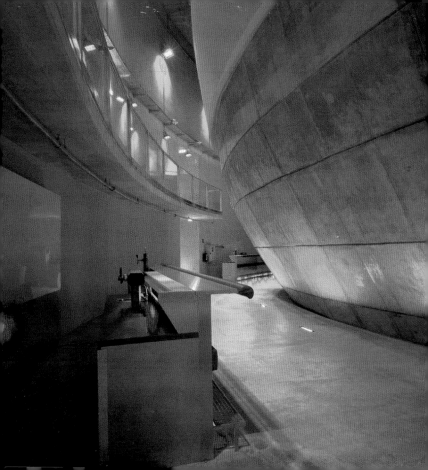

Miss Sargfabrik

BKK - 3 ZT - GmbH

2000
Goldschlagstraße 169
14. Bezirk

www.sargfabrik.at
www.bkk-3.com

Wohnen, Arbeiten und Kultur unter einem Dach: Das Gebäude beherbergt nicht nur Apartments, sondern auch eine Bibliothek, ein Schwimmbad, Büroräume und eine Gemeinschaftsküche zum Feiern. In den 39 Wohneinheiten formen geknickte Wände und schiefe Böden oder Decken konkave oder konvexe Zimmer.

Living, working and cultural space under one roof: the building not only houses apartments, but also a library, swimming pool, office space and a shared kitchen for celebrations. Curved walls and uneven floors or ceilings in the 39 apartment units form concave or convex rooms.

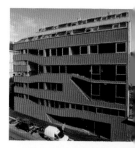

Habitat, travail et culture sous un même toit : le bâtiment abrite non seulement des appartements, mais aussi une bibliothèque, une piscine, des bureaux et une cuisine commune pour faire des fêtes. Dans les 39 unités d'habitation, des murs en décrochement et des sols ou des plafonds inclinés forment des pièces convexes ou concaves.

Vivienda, trabajo y cultura bajo un techo: El edificio no solamente aloja apartamentos, sino también una biblioteca, una piscina, oficinas y una cocina común para celebraciones. En las 39 unidades habitables las paredes plegadas y los suelos o techos inclinados forman habitaciones cóncavas o convexas.

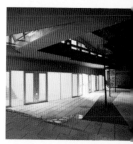

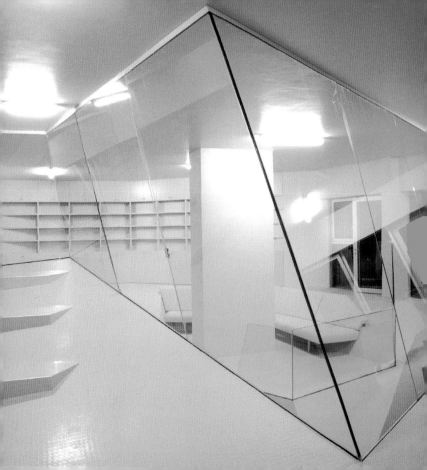

Gartenhaus Arato

Garden House

SGLW+S Architekten
Gmeiner & Haferl Tragwerksplanung (SE)

2004
Rosental
14. Bezirk

www.sglw.at

Passend zur Lage in einer der ältesten Gartensiedlungen Wiens, setzt das Gebäude auf eine Ästhetik des Improvisierten: Es erinnert an eine Laube, die aus den verschiedensten Materialien zusammengezimmert ist. Gleichzeitig sorgen jedoch rahmenlose Verglasungen für einen Hauch von Hightech-Noblesse.

In keeping with the location, in one of Vienna's oldest garden residential complexes, the impact of the building counts on an aesthetic of improvised elements: it is reminiscent of greenery that a carpenter has put together out of the most diverse materials. At the same time, frameless windows ensure a touch of high-tech finesse.

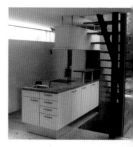

Dans une des plus anciennes cités jardin de Vienne, le bâtiment s'adapte à la situation en misant sur une esthétique de l'improvisation : il rappelle une cabane de jardin faite d'un assemblage hétéroclite de matériaux. En même temps, des vitrages sans châssis lui confère un caractère hightech plus noble.

Apropiado para la zona en uno de los complejos de jardines más antiguos de Viena, el edificio apuesta por una estética de lo improvisado: Recuerda a una glorieta construida uniendo los materiales más diferentes. Sin embargo, los acristalamientos sin marcos proporcionan al mismo tiempo un toque de nobleza de alta tecnología.

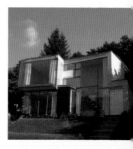

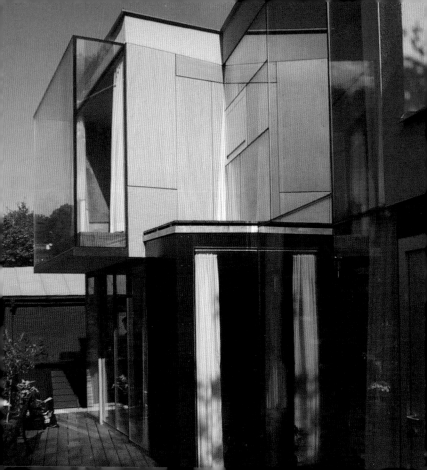

Parkhouse

Mark Gilbert Architektur + HOLODECK.at
Gmeiner & Haferl (SE)

2002
Krafft-Ebing-Gasse 3
14. Bezirk

www.mgilbert.at
www.holodeck.at

Die Architekten spielten das ge- stalterische Thema der Faltung an einem kleinen Einfamilienhaus durch, das auf einem parkähn- lichen Gelände steht: Wie ein durchgehendes Band wickeln sich Boden, Wand und Decke um die Räume. An der höchsten Stelle liegt das Elternzimmer wie ein Vogelhorst mit Ausblick.

The architects tried out a fold design element on a small, de- tached family home, located in a parkland plot: floor, wall and ceiling wind like a continual ribbon through the rooms. The master bedroom is right at the top like an oversized bird's nest with a view.

Pour cette maison particulière donnant sur un parc, les architec- tes ont joué d'un bout à l'autre sur le thème du pliage : comme un ruban qui se déploie, sol, mur et plafond s'enroulent autour des pièces. Tout en haut se trouve la chambre des parents comme un nid d'oiseau avec vue.

Los arquitectos tocaron el tema creador del plegado en una pe- queña casa unifamiliar situada en un terreno similar a un parque: El suelo, la pared y el techo se envuelven alrededor de las habitaciones como una banda continua. En el punto más alto se encuentra el cuarto de los pa- dres como un nido de pájaros con vistas.

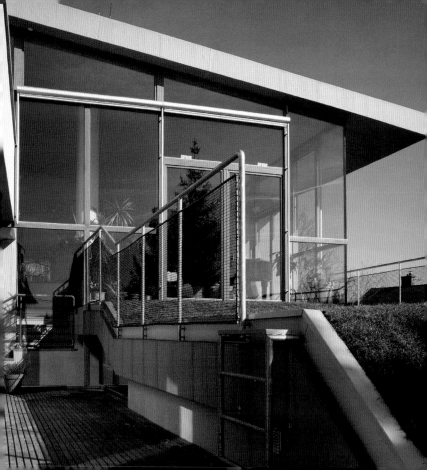

Remise Ottakring

Depot

Kopper Architektur, Croce & Klug
Gmeiner & Haferl Tragwerksplanung (SE)

2000
Joachimsthaler Platz 1
16. Bezirk

www.kopperarchitektur.at

In den unteren Geschossen des Gebäudes liegt ein Straßenbahndepot, das sich in der Fassade mit typografisch bedruckten Glasflächen abzeichnet. Darüber ordneten die Architekten Wohnungen an, teils als Maisonette, und eine halböffentliche Grünfläche, die über Rampen mit der Straße verbunden ist.

A tram depot is located on the building's lower floors. This is reflected in the façade with frosted glass plates, featuring a typographical design. The architects drew plans for apartments in the upper floors. These are partly designed as maisonettes, as well as a semi-public green area, which is connected to the street by ramps.

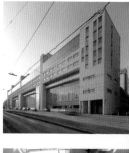

Dans les premiers étages de cet immeuble se trouve un dépôt de tramways que l'on retrouve sur la façade au travers des parois vitrées imprimées de caractères typographiques. Au-dessus, les architectes ont agencé des appartements, en partie en duplex, et un espace vert semi-public, qui est relié à la rue par des rampes.

En los pisos más bajos del edificio se encuentra un depósito de tranvías que se vislumbra en la fachada con superficies de vidrio impresas de modo tipográfico. Sobre ellos los arquitectos colocaron viviendas, en parte como maisonettes, y una zona verde semipública que está unida a la calle por rampas.

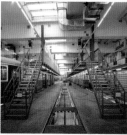

Pilotprojekt
Homeworkers

BUSarchitektur
Kollitsch & Stanek, Ewald Pachler (SE)

2002
Donaufelder Straße 101
21. Bezirk

www.busarchitektur.com

Ein ganzer Straßenblock von einem einzigen Architekturbüro entworfen – was meist zu funktionaler wie gestalterischer Monokultur führt, ergab hier einen feinmaschigen Nutzungsmix aus Geschäften, Wohnungen, Büros und Werkstätten. Abwechslungsreiche Fassaden in kräftigen Farben leuchten auch an trüben Tagen.

An entire residential street was designed by a single architect's studio. In this case, what usually ends up as a monoculture, both in terms of design and function, turned out as a finely balanced selection of shops, apartments, offices and workshops. Various styles of façade in strong colors even brighten up a dismal day.

Toute une partie de rue conçue par un seul bureau d'architecture ; ce qui conduit souvent tant au niveau fonctionnel qu'esthétique à un ensemble monotone, apparaît ici comme une fine trame composée de magasins, appartements, bureaux et ateliers. Des façades variées aux couleurs vives brillent même quand le temps est gris.

Un bloque entero proyectado por una única oficina de arquitectos –lo que en su mayoría lleva a una monocultura tanto funcional como creadora dio aquí como resultado una fina mezcla de aprovechamientos de tiendas, viviendas, oficinas y talleres. Las fachadas variadas en colores fuertes están iluminadas también en los días nublados.

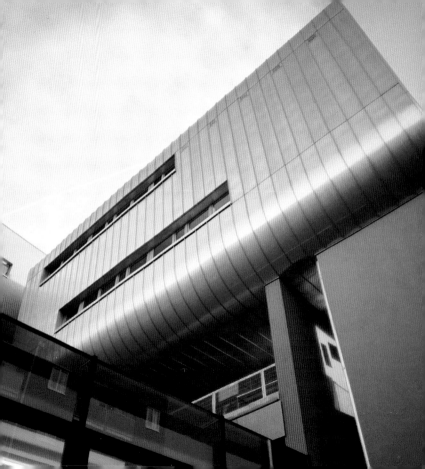

Der runde Wagramer

Peichl & Partner
W. Potyka, Dorr-Schober & Partner (SE)

1998
Wagramerstraße 25
22. Bezirk

www.peichl-partner.at

Den Spitznamen „Obelixturm" verdankt das Wohnhochhaus seiner blau-weiß gestreiften Fassade, die den Baukörper schlanker erscheinen lässt, als er ist. In jedem Geschoss finden vier Wohnungen Platz, deren Loggia in den Baukörper eingeschnitten ist und sich mit einem Glasschiebefenster schließen lässt.

The high-rise apartment block by the nickname of "Obelix Tower" owes its name to the blue and white striped front that makes the building appear slimmer than it is. There is space for four apartments on every floor with loggia style balconies, which are set into the building and can be shut off by a simple, sliding French window.

Le bâtiment d'habitation doit son surnom « tour Obélix » à sa façade rayée bleu et blanc, qui fait apparaître le corps du bâtiment plus fin qu'il n'est en réalité. A chaque étage se trouvent quatre appartements dont la loggia, découpée dans le corps du bâtiment, se ferme par une baie vitrée coulissante.

El alto edificio de viviendas debe su sobrenombre de "torre de Obélix" a su fachada pintada en azul y blanco la cual hace que el cuerpo de la construcción parezca más delgado de lo que es. En cada piso encuentran espacio cuatro viviendas cuya loggia está cortada en el cuerpo de la construcción pudiendo cerrarse con una ventana corredera.

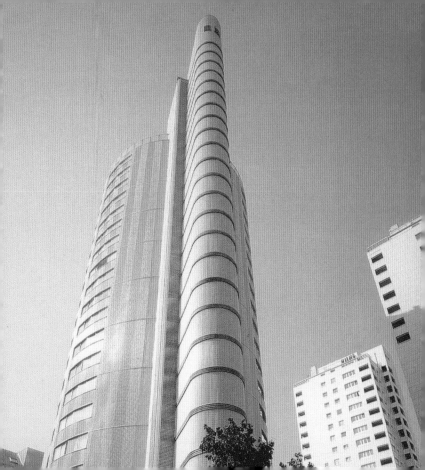

Balken 1

Delugan Meissl Associated Architects

1998
Leonard-Bernstein-Straße 4-6
22. Bezirk

www.deluganmeissl.at

Der 180 Meter lange Riegel beherbergt 190 Wohnungen. Er stützt sich auf schlanke Betonpfeiler, die je nach Perspektive so unauffällig sind, dass er über dem Ufer der Neuen Donau zu schweben scheint. Die gewaltige Großform muss sich im Umfeld der Donaucity mit seinen wenig attraktiven Hochhäusern behaupten.

The 180 meters long block accommodates 190 apartments. It is supported on thin, concrete posts that are so unobtrusive, whichever angle you look at them, that the building seems to float above the banks of the New Danube. The gigantic scale of the structure has to be distinguishable in the surroundings of Danube City with its rather unattractive, high-rise buildings.

Cette barre de 180 mètres de long abrite 190 appartements. Elle repose sur de fins piliers de béton si discrets que selon la perspective, elle semble flotter au-dessus des rives du Nouveau Danube. L'imposante forme doit trouver sa place dans le cadre de la Donau-city dont les bâtiments de grande hauteur sont peu séduisants.

El cuerpo alargado de 180 metros de longitud aloja 190 viviendas. Se apoya en delgados pilares de hormigón que, dependiendo de la perspectiva, son tan discretos que parece estar suspendido sobre la orilla del Nuevo Danubio. La inmensa forma debe afirmarse en el entorno de la Donaucity con sus edificios altos poco atractivos.

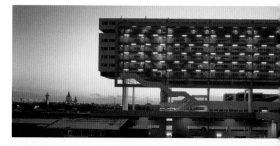

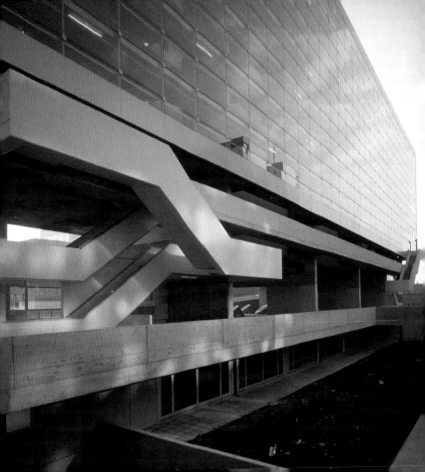

Büropavillon im Wiener Rathaus

Office Pavilion at the City Hall

Oliver Kaufmann

2000
Rathaus Hof 2
1. Bezirk

www.kaufmannwanas.com

In einen Hof des Wiener Rathauses wurde, als Kontrast zu den massiven Steinmauern, ein leichter Rundbau implantiert. Die Verbindung zum bestehenden Rathaus erfolgt über eine verglaste Brücke. Ein zentrales kreisrundes Foyer erschließt die tortenstückförmigen, unterschiedlich großen Büroräume.

A light rotunda was transplanted into a courtyard of Vienna's City Hall in contrast to the building's imposing stone masonry. A glass walkway connects the new structure with the existing city hall. A circular foyer in the center gives access to the office space, of varying sizes and shaped like pieces of cake.

Dans la cour de l'Hôtel de Ville de Vienne, on a construit un bâtiment rond et léger qui contraste avec les lourds murs de pierre. Un passerelle vitrée le relie au bâtiment de l'Hôtel de Ville existant. Les bureaux, plus ou moins grands, sont en forme de triangle dont la pointe s'ouvre sur un vestibule circulaire.

En un patio del Ayuntamiento de Viena se implantó una liviana construcción circular como un contraste con los masivos muros de piedra. La unión con el Ayuntamiento existente se efectúa por un puente acristalado. Un vestíbulo central redondo agrupa las oficinas en forma de torta y de diferentes tamaños.

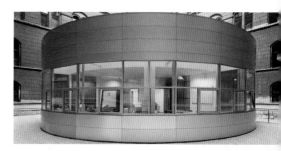

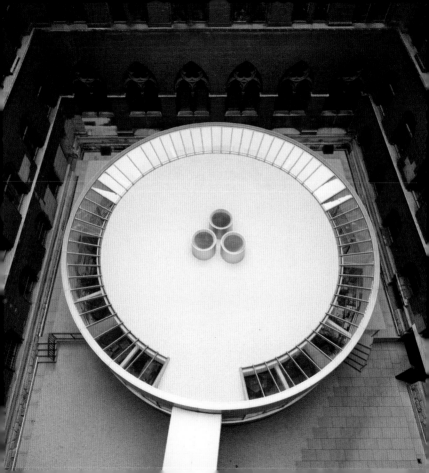

Gesundheitsamt Schottenring

Department of Health

Patricia Zacek Architektin

2002
Schottenring 22-24
1. Bezirk

www.patricia-zacek.at

Der Eingangsbereich des Amts, das in einem wuchtigen Bau aus dem 19. Jahrhundert untergebracht ist, erhielt ein neues Gesicht. Der Solidität des alten Prachtbaus setzte die Architektin filigrane Glaswände, einen horizontal gegliederten, scheinbar schwebenden Empfangstresen und leuchtende Farben entgegen.

The entrance hall of the office in a rambling, 19th century building has been given a face-lift. The architect chose filigree glass walls to contrast with the solid structure of the old, majestic building, a horizontal design on an almost floating reception desk, and vivid colors.

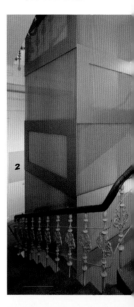

Le hall d'entrée de cette administration, qui se trouve dans un imposant bâtiment du 19ème siècle, a pris une nouvelle apparence. A la solidité du vieux palais, l'architecte a opposé des murs de verre en filigrane, la structure horizontale du poste d'accueil qui semble flotter dans l'espace et des couleurs vives.

El recinto de entrada a la Oficina, alojada en una maciza edificación del siglo XIX, recibió una nueva imagen. A la solidez del fastuoso edificio antiguo la arquitecta contrapuso paredes de vidrio de filigrana, un mostrador de recepción estructurado horizontalmente –aparentemente suspendido– y colores luminosos.

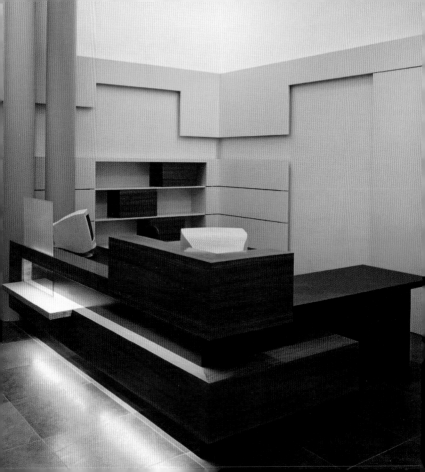

Diana Bürohochhaus und Erlebnisbad

High-Rise Office Block and Adventure Pool

Atelier Hayde Architekten

2000
Lilienbrunngasse 7-9
2. Bezirk

www.hayde.at

Die Bedingung, um auf dem Grundstück eines ehemaligen Schwimmbads ein Bürohochhaus errichten zu dürfen, war, auch ein Erlebnisbad zu bauen. Als additive Fügung unterschiedlicher Baukörper – am dominantesten ist eine flache Scheibe – präsentieren sich nun die Büros für 600 Arbeitsplätze in luftiger Höhe.

The condition for obtaining permission to build an high-rise office block on the site of a former swimming pool was to include an adventure pool. Offices for up to 600 employees now soar into the sky and complement the building by the addition of different structures. The most eye-catching one is a flat disc.

Inclure la construction d'un espace aquatique était la condition pour être autorisé à ériger un immeuble de bureaux sur l'emplacement d'une ancienne piscine. Les bureaux prévus pour 600 personnes s'élèvent dorénavant dans les airs en un groupe de bâtiments différents. Une construction plate en forme de disque domine l'ensemble.

La condición para que se permitiera erigir un bloque de oficinas en el solar de una antigua piscina fue que también se construyera un parque acuático. Como coincidencia adicional de los cuerpos arquitectónicos diferentes –el que más domina es un disco plano– las oficinas se presentan ahora para 600 puestos de trabajo en altitud aérea.

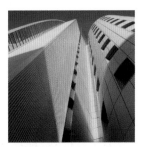 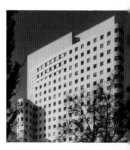

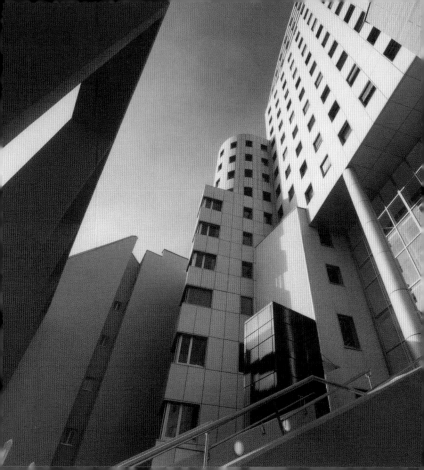

IBM Österreich Hauptverwaltung

Headquarter

Rudolf Prohazka

2001
Obere Donaustraße 95
2. Bezirk

www.prohazka.at

Ein Bürohaus aus den 60er Jahren erhielt ein neues Dachgeschoss und eine neue Fassade: Eine leicht nach außen gewölbte Glasmembran spannt sich als zweite Haut über das bestehende Betonraster. Sie verleiht dem Bau ein neues Erscheinungsbild, lässt aber gleichzeitig die vorhandene Struktur durchscheinen.

A 1960s office block was extended by a new top storey and façade: a glass membrane, which is slightly convex, stretches like a new skin over the existing cement shell of the building. This gives the structure a new look, while preserving the original features.

La façade a été refaite et le combles ont été aménagé dans cet immeuble de bureau des années soixante : une membrane de verre légèrement bombée vers l'extérieur est tendu comme une seconde peau s la trame de béton en laissa cependant apparaître en mêm temps la structure existante.

Un edificio de oficinas de los años 60 recibió un nuevo ático y una nueva fachada: Una membrana de vidrio arqueada ligeramente hacia afuera se extiende como una segunda piel sobre la cuadrícula de hormigón existente. Proporciona una nueva apariencia a la edificación pero, al mismo tiempo, deja filtrar la estructura existente.

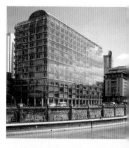

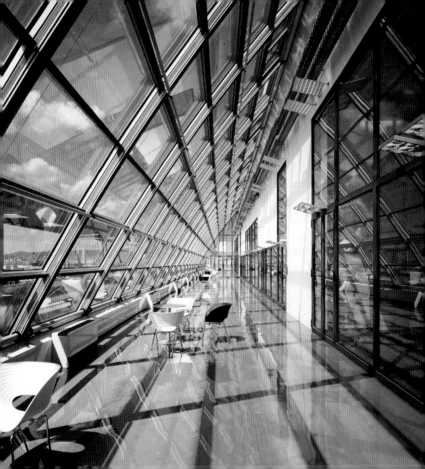

Ellipse

Mascha & Seethaler

2002
Juchgasse 22a
3. Bezirk

www.architects.co.at

Der elliptische Bau setzt sich als Solitär von der orthogonalen gründerzeitlichen Blockrandbebauung der Umgebung ab. Ein modernes Klimakonzept mit Bauteilkühlung in den Betondecken soll eine Überhitzung der Büros verhindern, die durch die großflächig verglaste Fassade entstehen könnte.

The elliptical shape contrasts as a distinctive style against the orthogonal development of surrounding buildings of the late nineteenth century. A modern air-conditioning plan, which incorporates cooling elements in the concrete ceiling, is intended to prevent the offices overheating. This could be caused by the large amount of glass used in the building's façade.

La construction elliptique se détache comme un solitaire de l'ensemble orthogonal, construit à la fin du 19^{ème} siècle, qui l'entoure. Un système de climatisation moderne avec des éléments de refroidissement intégrés dans les plafonds de béton doit éviter une surchauffe des bureaux qui pourrait se produire en raison de la grande façade de verre.

La construcción elíptica se destaca solitaria de la edificación ortogonal de bloques al margen situada en los alrededores y surgida en la época de la expansión industrial. Una concepción climática moderna con enfriamiento de las partes del edificio en los techos de hormigón ha de impedir un sobrecalentamiento de las oficinas que podría surgir por la amplia fachada acristalada.

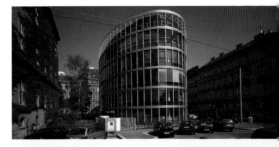

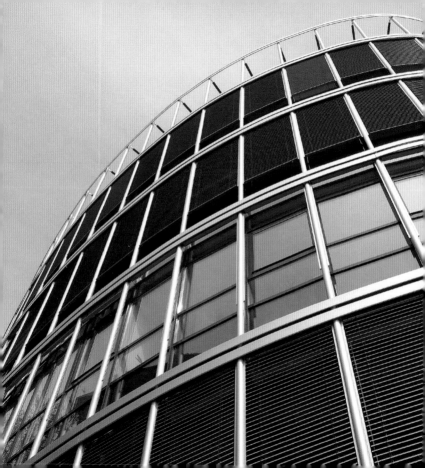

Monte Laa, Porr Towers

Hans Hollein Architekt

2005
Waltenhofengasse /
Laaer Berg Straße
10. Bezirk

www.hollein.com

Über der A22, einer der Haupt-einfallstraßen von Süden, ent-steht der neue Stadtteil Monte Laa. Die Türme sollen für den Ankommenden den Stadtein-gang markieren. In den aus-kragenden Baukörpern an der Spitze, eine Idee Hans Holleins aus den 60er Jahren, sollen Au-ditorien und Ausstellungsräume Platz finden.

The new district of Monte Laa is being developed over the A22, one of the main traffic routes into the city from the south. The tow-ers are to mark the entrance to the city for new arrivals. Auditoria and exhibition space is planned to fill the overhang sections at the top, one of Hans Hollein's ideas from the 1960s.

C'est au bord de l'A22, un des principaux axes d'accès sud de la ville, que se crée le nouveau quartier de Monte Laa. Ses tours indiquent à ceux qui arri-vent l'entrée de la ville. Tout en haut, dans la partie du bâtiment en saillie doivent prendre place des auditoriums et des salles d'exposition, selon une idée de Hans Hollein pendant les années soixante.

Por la A22, una de las principales carreteras de incidencia del sur, surge el nuevo barrio de Monte Laa. Las torres han de marcar la entrada a la ciudad para el que llega. En los cuerpos arquitectó-nicos que sobresalen en la punta –una idea de Hans Hollein de los años 60– han de hallar un lugar los auditorios y los espacios para exposiciones.

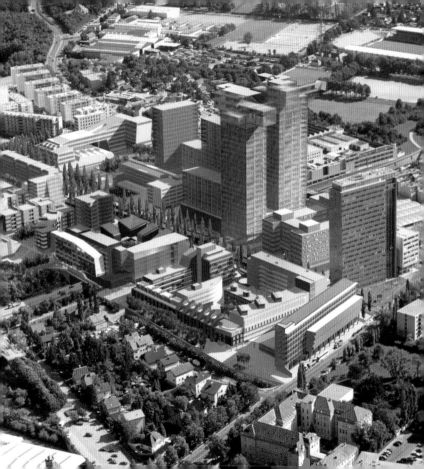

Twist Tower TT5

Georg Driendl

2002
Schönbrunner Straße 131
12. Bezirk

www.kallco.at
www.driendl.at

Die markante Betonung der Geschossdecken gliedert die Fassade horizontal, in Anlehnung an die Gesimse des bestehenden älteren Nachbargebäudes. Der Clou sind schräge Glasflächen, die in jedem Geschoss abwechselnd in gegenläufigen Richtungen von der Straßenflucht zurückspringen.

The distinctive marking of ceilings on each floor shapes the façade horizontally, in keeping with the cornices of the older building next door. The key to this design is the sloping, glass surfaces, which alternate on each floor in different directions from the alignment of the street.

L'accentuation marquée des plafonds des étages structure la façade horizontalement et rejoint la lignes des corniches du bâtiment voisin plus ancien. Le plus impressionnant ce sont les surfaces de verre obliques qui alternativement à chaque étage rebondissent dans des directions contraires à l'alignement de la rue.

La destacada acentuación de los techos de las plantas divide la fachada horizontalmente siguiendo el ejemplo de la cornisa del edificio vecino existente más antiguo. La atracción principal son las superficies acristaladas inclinadas que en cada planta saltan hacia atrás de forma alternada y desde la alineación en direcciones contrarias.

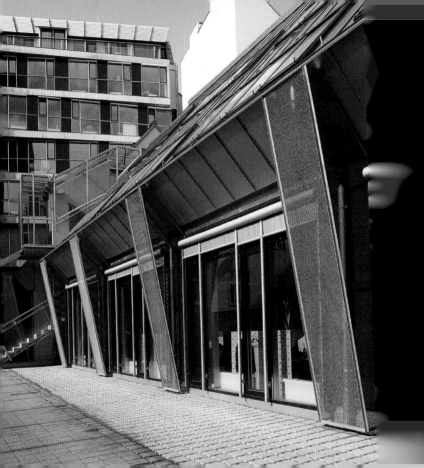

Büro- und Fitnesscenter
Hütteldorferstraße
Office and Fitness Center

Rüdiger Lainer

2003
Hütteldorferstraße 130
14. Bezirk

www.lainer.at

Bei der Ergänzung zu einem bestehenden Gebäude entschied sich der Architekt für eine ornamentale Fassade. So wie beim Altbau Sichtmauerwerk vor das Stahlbetonskelett geblendet ist, verkleidete er seine Stahlkonstruktion mit einer reliefartigen Haut aus Aluminiumgusstafeln mit Pflanzenmotiven.

The architect chose an ornamental façade to complement an existing structure. In a similar way as stone masonry is left visible in front of a steel structure on a listed building, he concealed his steel frame with a layer of aluminum plates with botanic motifs and set in relief.

L'architecte qui a agrandi le bâtiment déjà existant a opté pour une façade ornementale. De la même façon que dans les bâtiments anciens les murs de pierre sont doublés d'un squelette de béton armé, il a recouvert sa construction métallique d'un revêtement en relief constitué de plaques d'aluminium coulé décorées de motifs végétaux.

Para ampliar un edificio existente, el arquitecto se decidió por una fachada ornamental. Así como en el edificio antiguo la mampostería visible está simulada delante del esqueleto de hormigón armado, aquél revistió su construcción de acero con una piel a modo de relieve hecha de paneles fundidos de aluminio con motivos de plantas.

IP Two Business Center

BKK - 3 ZT - GmbH

2003
Lerchenfelder Gürtel 43
16. Bezirk

www.bkk-3.com

An einer Straßenecke im 16. Bezirk liegt ein Gründerzentrum, das mit üblichen Vorstellungen über Bürobauten aufräumt: Ein biomorphes Treppenhaus, schräge Wände, schiefe Böden und geneigte Decken sprengen den Rahmen normierter Investorenarchitektur. Die expressive Fassade ist ein Blickfang im Quartier.

On a street corner in Vienna's 16th district, there is a center for new business enterprises that defies all the conventional ideas about office buildings: a biomorphic stairwell, sloping walls, uneven floors and ceilings at an incline do not fit the mould of regular investor's architecture. The expressive façade is an eye-catching feature of the district.

À un angle de rue dans le 16ème arrondissement, il y a un bâtiment abritant une pépinière d'entreprises qui fait table rase des idées habituelles que l'on se fait sur des immeubles de bureaux. Sa cage d'escalier biomorphique, ses murs obliques, ses sols en pente et ses plafonds inclinés sont atypiques. La façade expressive est l'attraction du quartier.

En una esquina del distrito 16 se halla un centro de fundadores que acaba con las ideas habituales acerca de los edificios de oficinas: Una escalera biomorfa, paredes oblicuas, suelos torcidos y techos inclinados superan los límites de la arquitectura de inversores estandarizada. La expresiva fachada es un blanco de las miradas en el barrio.

Logistic Center
Telekom Austria

Petrovic & Partner Architekten

2002
Perfektastraße 85
23. Bezirk

www.ppa-arc.com

Bei Umbau, Aufstockung und Erweiterung einer Industriehalle aus der Nachkriegszeit galt es, die Gebäudehülle für die Unternehmenskommunikation nutzbar zu machen. Kräftige, leuchtende Farben, in spielerischer Anordnung über die Fassade verteilt, sollen Innovation und Modernität ausdrücken.

The brief for redevelopment, including adding extra levels and extending a post-war industrial workshop, was to make the shell of the building suitable for commercial communication. Strong, vivid colors were playfully arranged over the façade as an expression of innovation and modernity.

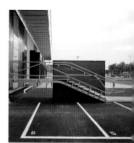

Lors des travaux de transformation, surélévation et agrandissement d'une halle industrielle de l'après-guerre il a été décidé d'utiliser l'enveloppe du bâtiment pour la communication d'entreprise. Un jeu de couleurs vives et lumineuses dispersées sur la façade doit exprimer l'innovation et la modernité.

Para la reforma, sobreedificación y ampliación de una nave industrial de la época de la posguerra se trataba de hacer aprovechable la cubierta del edificio para la comunicación de la empresa. Los colores fuertes, luminosos, distribuidos sobre la fachada de forma juguetona, han de expresar innovación y modernidad.

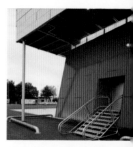

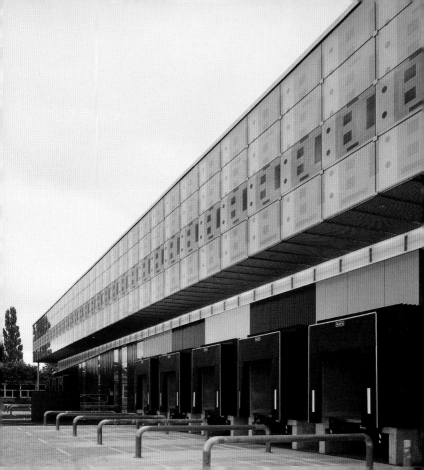

Albertina Museum

Architekten Steinmayr Mascher
Robert Harrauer & Wolfgang Tötzel (SE)

2002
Albertinaplatz 1
1. Bezirk

www.albertina.at
www.steinmayr-mascher.com

Die Räumlichkeiten der grafischen Sammlung in einem Palais neben der Hofburg erhielten eine Erweiterung. Der Neubau bleibt in seiner Höhe deutlich hinter dem Bestand zurück – teils wurde er sogar ins Erdreich versenkt – und verstellt daher kaum den Blick auf das historische Ensemble.

The rooms housing the graphic collection in a palace near to Vienna's Imperial Palace were extended. The new building is visibly lower than the existing rooms and part of it was even sunk into the ground. In that way, the extension hardly interferes at all with the view of the historical building ensemble.

Les locaux de la collection d'ar graphiques qui se trouve dan un palais près du Hofburg o été agrandis. La hauteur de construction neuve reste ne tement en-dessous de celle d bâtiment existant, elle est mêm en partie enfoncée dans le so ce qui fait qu'elle ne gêne pres que pas la vue sur l'ensembl historique.

Las salas de la colección gráfica en un palacio junto al Hofburg recibieron una ampliación. La nueva edificación permanece en su altura claramente por debajo del existente –en parte fue incluso hundida en el terreno– y por eso apenas obstruye la mirada hacia el conjunto histórico.

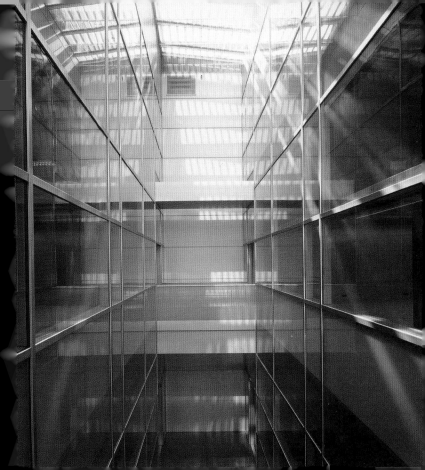

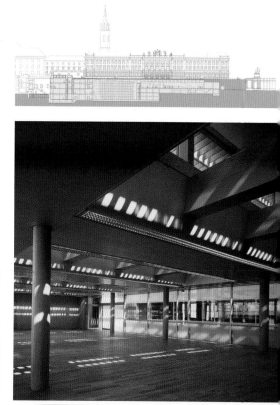

28. **Soravia-Wing**
Albertina
Hans Hollein Architekt

2004

www.albertina.at
www.hollein.com

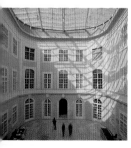

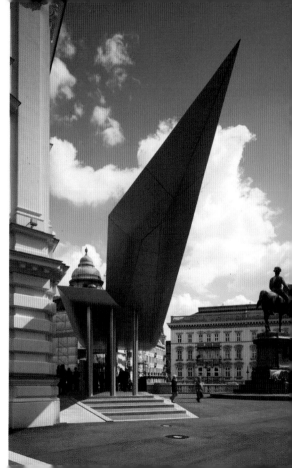

Wiener Musikverein

Dieter Irresberger, Wilhelm Holzbauer

2004
Bösendorferstraße 12
1. Bezirk

www.musikverein.at
www.holzbauer.com

Der traditionsreiche Wiener Musikverein erhielt vier neue Säle, die der Architekt unter dem Vorplatz des historischen Gebäudes in die Erde baute, um das Denkmal nicht antasten zu müssen. Jeder Saal hat ein anderes Material zum Thema: Glas, Stein, Metall und Holz dominieren jeweils den Raum.

Vienna's Musikverein, a building steeped in tradition, was given four new rooms, which the architect built downwards, under the square in front of the historic building. The idea was not to interfere with the original listed building. Every room is themed on a different material: glass, stone, metal and wood each dominate the space.

L'Association de musique de Vienne qui jouit d'une longue tradition a été dotée de quatre nouvelles salles, que l'architecte a construites sous la place devant le bâtiment historique, afin de ne pas porter atteinte au monument. Chaque salle a pour thème un matériau différent : le verre, la pierre, le métal et le bois dominent ainsi alternativement dans chacune des salles.

La Asociación Vienesa de Músicos, repleta de tradición, recibió cuatro salas nuevas que el arquitecto construyó en el terreno debajo de la explanada del edificio histórico para no tener que tocar el monumento. Cada sala tiene como tema un material diferente: Vidrio, piedra, metal y madera dominan respectivamente el espacio.

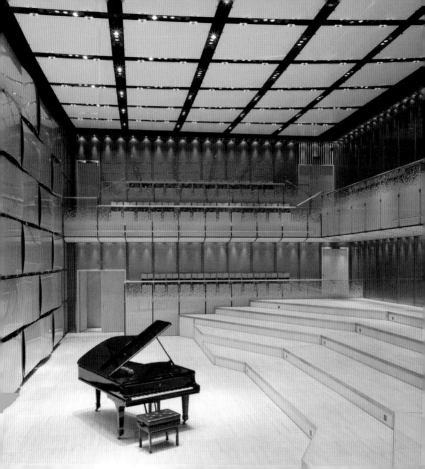

Urania

Dimitris Manikas Architekten

2003
Uraniastraße 1
1. Bezirk

www.urania-wien.at
www.dimitrismanikas.com

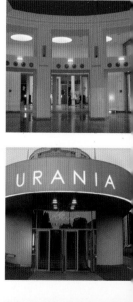

Das 1909 errichtete Volksbildungshaus wurde saniert, wobei die zahlreichen Umbauten der vergangenen Jahre ablesbar bleiben sollten. Der Bau enthält heute Kino, Puppentheater, Bibliothek, Sternwarte, Vortragssäle, Werkstätten, und ein Café, das als verglaster Baukörper über den Donaukanal auskragt.

This public educational building, erected in 1909, was renovated so that numerous redevelopments from previous years remained visible. Today, the building houses a cinema, a puppet show, library, observatory, lecture theatres, workshops and a café, whose glass structure juts out across the Danube Canal.

Le bâtiment de 1909 et dédié à l'éducation populaire a été rénové. Les transformations des années passées devaient rester visibles. Le bâtiment contient un cinéma, un théâtre de marionnettes, une bibliothèque, un observatoire, des salles de conférence, des ateliers et un café aménagé dans une partie vitrée de la construction qui fait saillie au-dessus du canal du Danube.

La casa para la formación popular erigida en 1909 fue saneada habiendo de quedar reconocibles las numerosas reformas de los años pasados. La edificación contiene hoy cine, teatro de marionetas, biblioteca, observatorio astronómico, salas de conferencias, talleres y un café que sobresale sobre el canal del Danubio como un cuerpo arquitectónico acristalado.

72

project space Kunsthalle Wien

Adolf Krischanitz

2001
Karlsplatz
1. Bezirk

www.kunsthallewien.at
www.krischanitz.at

In dem Glaspavillon ist junge, zeitgenössische Kunst zu sehen. Sie wird nicht hinter steinernen Mauern versteckt, sondern wie in einem Schaufenster präsentiert – ein Versuch, sie mit dem täglichen Leben zu verschränken, unterstrichen auch von dem riesigen plakativen Schriftzug auf der Fassade.

Young, contemporary art is exhibited in the glass pavilion. It has not been hidden behind stonewalls, but rather, the art is presented like a showcase, in an effort to include the pavilion in everyday life. The enormous, declamatory writing on the façade also underlines this purpose.

Dans le pavillon de verre on peut voir de l'art contemporain récent. Il n'est pas caché derrière des murs de pierre mais au contraire présenté comme dans une vitrine. C'est une tentative de provoquer la rencontre de l'art et de la vie quotidienne, qui est aussi mise en exergue avec l'immense graphisme décoratif de la façade.

En el pabellón acristalado puede verse arte joven y contemporáneo. No se esconde detrás de unos muros de piedra sino que se presenta como en un escaparate –un intento de cruzarlo con la vida cotidiana– acentuado también por la enorme y llamativa palabra escrita sobre la fachada.

MuseumsQuartier

Ortner & Ortner Baukunst (Leopold Museum, MUMOK, Kunsthalle)
Manfred Wehdorn (Renovation)
Fritsch, Chiari & Partner (SE)

2001
Museumsplatz 1
7. Bezirk

www.mqw.at
www.ortner.at
www.wehdorn.at

In den ehemaligen Hofstallungen, ab 1713 von Fischer von Erlach errichtet, hielten mehrere Kunstsammlungen und das Architekturzentrum Wien Einzug. Zwei Neubauten, einer in hellem Sandstein, der andere in schwarzem Basalt, verstecken sich bescheiden im Innenhof, um dem Denkmal nicht die Schau zu stehlen.

Several art collections and Vienna's architectural center relocated to the site of the former court stables, dating back to 1713, and built by Fischer von Erlach. The two new buildings are hidden discreetly away in the inner courtyard, so as not to steal the show from the listed building. The light sandstone of the one new building contrasts with the black basalt of the other.

C'est dans les anciennes écu ries du Palais, construites à pa tir 1713 par Fischer von Erlach qu'ont été installées plusieur collections d'art et le Centr d'architecture de Vienne. Deu nouveaux bâtiments, un en grè de couleur clair, l'autre en basa te noir, se cachent discrètemen dans la cour intérieure afin de n pas prendre plus d'importanc que le monument.

En las antiguas caballerizas de la corte, erigidas a partir de 1713 por Fischer von Erlach, hicieron su entrada varias colecciones de arte y el Centro de Arquitectura de Viena. Dos nuevas edificaciones, una en piedra arenisca clara, la otra en basalto negro, se ocultan modestamente en el patio interior para no robarle la vista al monumento.

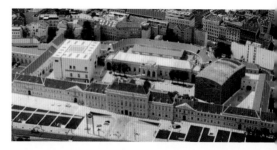

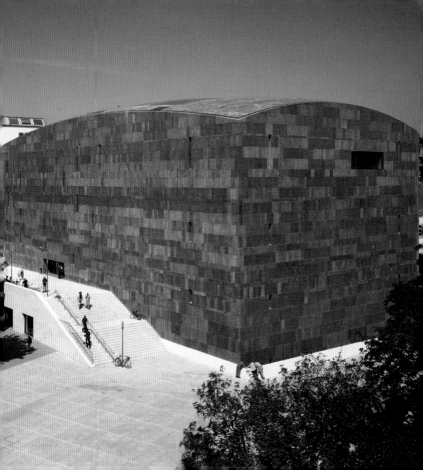

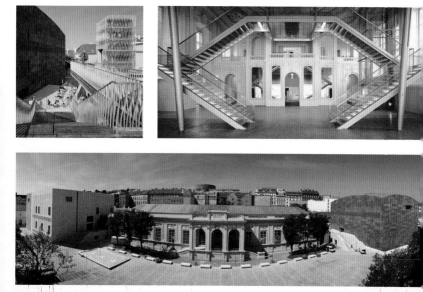

33. **Erste Bank Arena**
MuseumsQuartier
BEHF Architekten

2002

www.mqw.at
www.behf.at

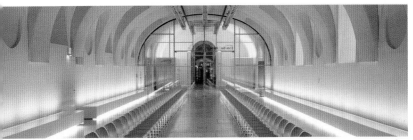

Electric Avenue

MuseumsQuartier

PPAG Popelka Poduschka Architekten

2002
Museumsplatz 1
7. Bezirk

www.mqw.at
www.ppag.at

In einem barocken Tonnengewölbe wurde eine Pavillonstruktur errichtet, die jungen Kulturinitiativen Raum bietet. Weil das bestehende Gemäuer aus Denkmalschutzgründen nicht angetastet werden durfte, entwarfen die Architekten eine zickzackförmige Raumfolge, die frei durch die Hallen mäandert.

A pavilion structure was built in a baroque barrel vault, in order to provide space for new cultural initiatives. The existing stonework could not be touched due to rules for listed buildings, so the architects designed a zigzag flow of different rooms, which meander freely through the halls.

Dans une halle baroque avec une voûte en berceau, on a construit une structure de pavillon offrant un espace pour des initiatives culturelles nouvelles. Le bâtiment étant classé monument historique, on ne devait pas porter atteinte aux murs existants. Les architectes ont conçu des espaces qui se suivent en zigzagant et font des méandres à travers les halles.

En una bóveda de cañón barroca se erigió una estructura de pabellón que ofrece un espacio para jóvenes iniciativas culturales. Dado que los muros existentes no podían tocarse por motivos de protección de monumentos, los arquitectos proyectaron una secuencia de espacios en forma de zigzag que fluye libremente por las salas como un meandro.

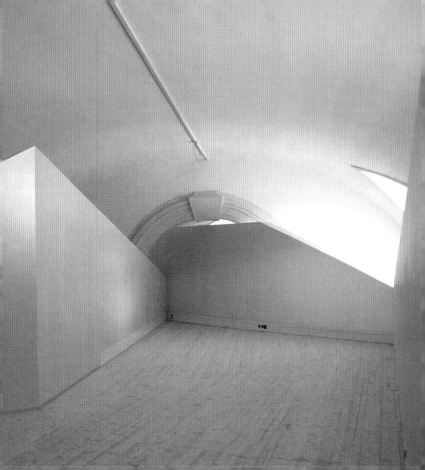

WestLicht
Schauplatz für Fotografie

Eichinger oder Knechtl

2001
Westbahnstraße 40
7. Bezirk

www.westlicht.com
www.eok.at

Sowohl Kameras als auch Fotografien sind in diesem Museum zu bestaunen, denn es sollen Querverbindungen zwischen dem Apparat und dem Medium aufgezeigt werden. In einem fünf Meter hohen Loft mit weißen Wänden und schwarzem Boden gibt es Ausstellungen historischer und zeitgenössischer Fotokunst zu sehen.

Cameras as well as photographs can be admired in this museum, which is to highlight crossovers between medium and equipment. Exhibitions of historical and contemporary photographic art can be viewed in a loft, which is five meters high and has white walls and a black floor.

Dans ce musée on peut admir aussi bien des appareils phc que des photographies, car veut mettre là en évidence l interactions entre l'appareil et médium. Dans un loft de ci mètres de haut aux murs blan et aux sols noirs on peut voir d expositions de photos ancienn et contemporaines.

En este museo pueden admirarse tanto las cámaras como las fotografías; pues han de mostrarse las conexiones entre el aparato y el medio. En un loft de cinco metros de altura con paredes blancas y suelo negro pueden verse exposiciones de arte fotográfico histórico y contemporáneo.

medien.welten
Technisches Museum Wien

Veit Aschenbrenner Architekten

2003
Mariahilfer Straße 212
14. Bezirk

www.tmw.at
www.vaarchitekten.com

Eine Ausstellungsgestaltung: Die Architekten zogen den Bodenbelag ein Stück die Wand hinauf, um dahinter die Installationen zu verbergen und darauf die Lichtfilter vor den Fenstern zu montieren. Bandartige Objektträger visualisieren durch ihre lineare Gestalt die zeitliche Entwicklung bei den Exponaten.

An exhibition design: the architects took the flooring up the wall by a margin that was sufficient to conceal installations behind it and to mount light filters on top of it in front of the windows. The chronological development of the exhibits is made visible by the linear form of the broad-based stands for the objects.

Une conception d'exposition : les architectes ont légèrement relevé le revêtement de sol sur les murs afin d'y cacher derrière les installations et d'y accrocher les filtres de lumières montés devant les fenêtres. Les présentoirs en forme de bandes permettent, de par leur forme allongée, la visualisation de l'évolution dans le temps des pièces exposées.

La creación de una exposición: Los arquitectos extendieron el revestimiento del suelo por la pared un poco hacia arriba para ocultar detrás las instalaciones y montar encima los filtros de luz delante de las ventanas. Los soportes de los objetos a modo de bandas visualizan la evolución temporal de las obras expuestas por medio de su forma lineal.

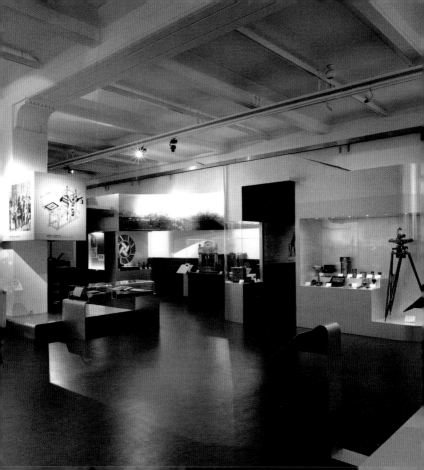

Städtische Bücherei

City Library

Mascha & Seethaler, Herwig Müller
Werkraum Wien (SE)

2004
Schwendergasse 39-43
15. Bezirk

www.buechereien.wien.at
www.architects.co.at

Im Jahr 2000 startete Wien eine „Bibliotheksoffensive": 45 Bezirksbüchereien wurden modernisiert, um ein jüngeres Publikum anzusprechen. In Wien-Fünfhaus erhielt das Gebäude ein poppiges Vordach, eine innen liegende Kinderrutschbahn und Rollregale, um den Raum auch für Veranstaltungen nutzen zu können.

In the year 2000, Vienna started a 'library offensive': 45 libraries in the city's districts were modernized, in order to appeal to a younger age group. In Vienna-Fünfhaus, the library building was given a colorful canopy, a children's slide in the interior and rolling shelves. The space could then also be used for meetings and events.

En 2000, la ville de Vienne a entrepris une « offensive dans le domaine des bibliothèques » : 45 bibliothèques de quartier ont été modernisées afin d'attirer un public plus jeune. La Fünfhaus de Vienne a été pourvue d'un avant-toit aux couleurs vives, d'un toboggan intérieur, d'étagères roulantes afin de pouvoir utiliser la salle aussi pour des manifestations.

En el año 2000 Viena inició una "ofensiva de bibliotecas": 45 bibliotecas de distritos fueron modernizadas para encontrar eco en un público más joven. En el barrio Fünfhaus de Viena el edificio recibió un colgadizo pop, un tobogán infantil situado en el interior y estanterías con ruedas para poder utilizar también el espacio para actos.

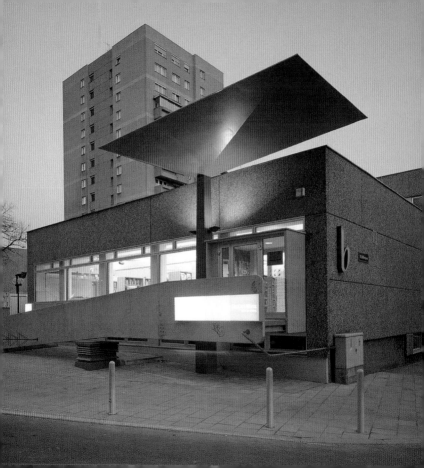

Donaucity Kirche

Church

Mag. Arch. Heinz Tesar
Arge Lindlbauer – Zehetner (SE)

2000
Donaucitystraße 2
22. Bezirk

www.donaucitykirche.at

Vor den riesigen Hochhäusern der Donaucity wirkt die Kirche mit ihrer Fassade aus schwarzen Chromstahlplatten wie eine kleine, wertvolle Schatulle und die innere Verkleidung aus Birkensperrholz, die sich über Wände und Decke zieht, wie das Futter. Winzige Rundfenster sorgen für stimmungsvolles Licht.

Against Danube City's giant skyscrapers, the church and its façade of black, chrome steel plates looks like a small, precious casket and the inner facing of birch plywood that covers the walls and ceilings looks like the lining. Miniscule, round windows give atmospheric light.

Devant les immenses immeubles de la Donau-city l'église avec sa façade en plaques de métal chromé et son habillage intérieur en contreplaqué de bouleau, qui recouvre les murs et le plafond, a l'air d'un petit écrin précieux. De très petites fenêtres rondes laissent passer une lumière propice au recueillement.

Ante los enormes rascacielos de la Donaucity la iglesia, con su fachada de placas de acero cromado, parece un pequeño cofrecillo valioso y el revestimiento interior de contrachapado de abedul, que se extiende sobre las paredes y el techo, parece el forro. Las minúsculas ventanas redondas procuran una luz acogedora.

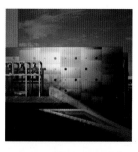

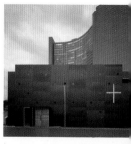

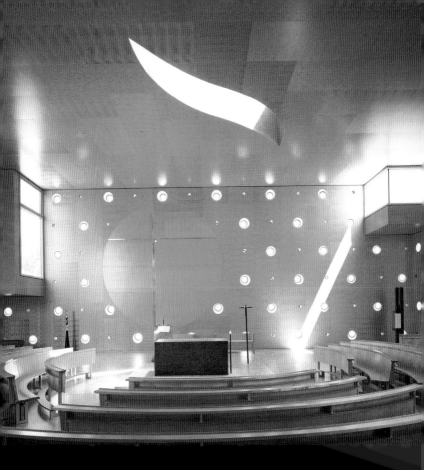

Museum Sammlung Essl

Mag. Arch. Heinz Tesar
Christian Aste, Pörtner + Partner (SE)

1999
An der Donau-Au 1
Klosterneuburg

www.sammlung-essl.at

In den Donauauen vor der Stadt steht dieses Kunstmuseum. Das Gebäude reagiert auf die Landschaft: Ein Betonsockel, der etwa ein Geschoss hoch ist, schützt die darüber liegenden Ausstellungsräume vor Hochwasser, das geschwungene Dach zeichnet die Linien des hügeligen Geländes nach.

This art museum is located in the Danube meadows outside the city. The building is a response to the landscape: a concrete plinth that is almost one storey high protects the exhibition halls above it from floodwaters. The swung roof imitates the lines of the undulating terrain.

Ce musée se situe au bord du Danube à l'entrée de la ville. Le bâtiment entre en dialogue avec le paysage : un socle en béton d'environ un étage met les salles d'exposition qui sont au dessus hors de portée des inondations. Le toit tout en courbes reprend les lignes du paysage de collines.

En las vegas del Danubio delante de la ciudad surge este museo de arte. El edificio reacciona al paisaje: Un zócalo de hormigón de aproximadamente una planta de altura protege de inundaciones las salas de exposiciones situadas sobre él y el techo oscilante imita las líneas del terreno montuoso.

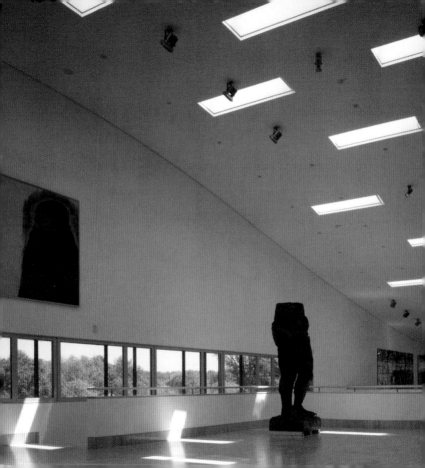

ÖBB Stellwerk Wien Süd-Ost

Signal Tower

Riepl Riepl Architekten
W. Stengel Zivilingenieure für Bauwesen, J. Stella (SE)

2002
Südbahnhof
10. Bezirk

www.rieplriepl.com

Ein kompakter Bauköper versucht, sich durch seine Klarheit in einem ungeordneten, heterogenen technischen Umfeld zu behaupten. Die Metallverkleidung nimmt die Materialität der vorbeifahrenden Züge auf, ein lang gestrecktes horizontales Bandfenster zeichnet ihre Bewegung nach.

A compact building attempts to make an impact by its clarity in an unstructured, heterogeneous, technical environment. The metal exterior adopts the material element of passing trains; and a long row of horizontal strip-windows imitates the movement.

Un corps de bâtiment compa tente de s'affirmer avec se lignes claires dans un enviro nement technique désordonn et hétéroclite. L'habillage c métal rappelle la matérialité de trains qui passent et une banc de fenêtres étirée en longue évoque leur mouvement.

Un cuerpo arquitectónico compacto intenta afirmarse por medio de su claridad en un entorno técnico heterogéneo sin orden. El revestimiento de metal acoge la materialidad de los trenes que pasan, una ventana de banda alargada imita su movimiento.

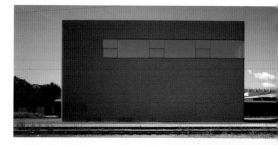

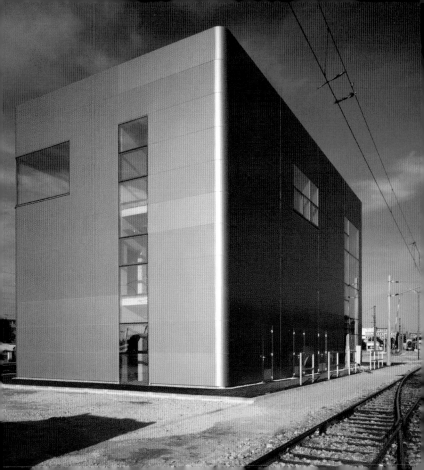

Messe Wien

Trade Fair

Peichl & Partner
Fritsch, Chiari & Partner (SE)

2003
Messeplatz 1
2. Bezirk

www.mbg.at
www.messe.at
www.peichl-partner.at

Drei Ausstellungshallen, ein Kongresszentrum und ein Turm prägen das neue Messezentrum auf dem Prater. Gustav Peichl entwickelte – wie auch bei anderen seiner Projekte – eine heitere, teils ironische Formensprache, die das Schema konventioneller, rein funktionaler Messearchitektur durchbricht.

Three exhibition halls, a congress center and a tower are the distinguishing features of Vienna's new trade fair in the Prater. As with other examples of his work, Gustav Peichl developed a lively, partly ironic form-language, which penetrates the scheme of conventional, purely functional exhibition architecture.

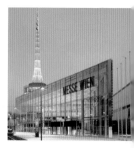

Trois halles d'exposition, un palais des congrès et une tour sont les marques de ce nouveau parc des expositions dans le Prater. Gustav Peichl a développé, comme aussi dans d'autres de ces projets, un langage des formes joyeux, parfois ironique, qui vient briser le schéma conventionnel et purement fonctionnel de l'architecture des parcs d'exposition.

Tres salas de exposiciones, un centro de congresos y una torre caracterizan el nuevo centro ferial en el Prater. Gustav Peichl desarrolló –como también en otros de sus proyectos– un lenguaje de formas alegre, en parte irónico, que rompe el esquema de la arquitectura ferial convencional, puramente funcional.

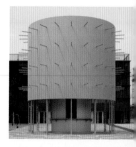

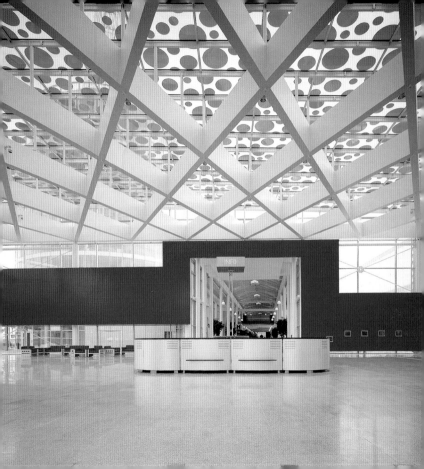

Wiener Riesenrad
Giant Ferris Wheel

Mathis Barz

2002
Prater 90
2. Bezirk

www.wienerriesenrad.com
www.barz.at

Das über 100 Jahre alte Riesenrad, Wahrzeichen des Praters, erhielt eine moderne Infrastruktur mit Laden, Café und Infopavillon. Ohne Berührungsängste fügte der Architekt die neuen Baukörper an das historische Monument – vielleicht etwas ungelenk. Ihre freie Form wiederholt sich bei den Tischen.

The Ferris wheel, a traditional trademark of the Prater and over a century old, has been modernized with a shop, café and information pavilion. The architect felt no qualms about adding new infrastructure to the historical monument, which is perhaps a little clumsy. The free form of the new structure is taken up again with the arrangement of tables.

La grande roue qui a plus de 100 ans, emblème du Prater, a été dotée d'une nouvelle infrastructure avec un magasin, un café et un pavillon d'information. Sans craindre de porter atteinte à l'apparence du monument historique, l'architecte lui a juxtaposé, peut-être un peu maladroitement, des éléments de construction neufs. La forme des tables reprend leurs lignes.

La noria gigante, con más de 100 años de antigüedad y marca característica del Prater, recibió una infraestructura moderna con tiendas, un café y un pabellón de información. Sin vacilaciones, el arquitecto ensambló los nuevos cuerpos arquitectónicos al monumento histórico –quizá un poco torpemente. Su forma libre se repite en las mesas.

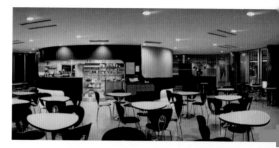

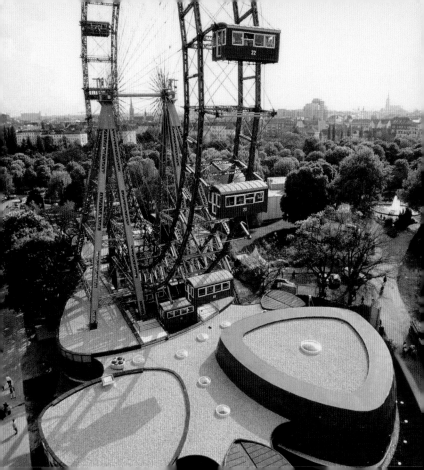

Parkdeck

Car Park

Gert M. Mayr-Keber

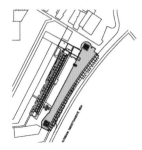

2002
Katharinengasse 10
10. Bezirk

www.mayr-keber.at

Der Bau liegt zwischen einer Stadtautobahn und einer Siedlung, er soll wie ein Lärmschutzwall wirken. In weitem Bogen folgt die Fassade der Kurve der Straße. In den oberen Geschossen machte die geringe Bautiefe eine Ausweitung erforderlich, die in Form von zweigeschossigen Park-Erkern ausgebildet wurde.

The building is situated between a city motorway and a residential area. The idea is that it functions like a protective wall of soundproofing. The façade follows the curve of the road in a wide bend. On the upper levels, the minimal building substance made it necessary to extend the structure, which was achieved in the form of dual level parking bays.

Le bâtiment est situé entre l[e] boulevard périphérique et un[e] cité et doit remplir le rôle d[e] protection antibruit. La façad[e] largement arquée suit la courb[e] de la rue. La construction étan[t] peu profonde, il était nécessair[e] de l'élargir dans les étages su[-] périeurs en construisant un[e] partie en encorbellement su[r] deux étages.

La edificación se halla entre una autopista y una zona residencial y ha de producir el efecto de una pared de protección contra el ruido. En amplio arco, la fachada sigue la curva de la carretera. En las plantas superiores la pequeña profundidad de la edificación hizo necesaria una ampliación la cual fue configurada en forma de miradores del parking de dos plantas.

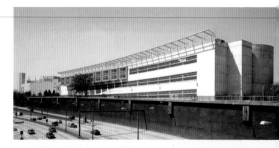

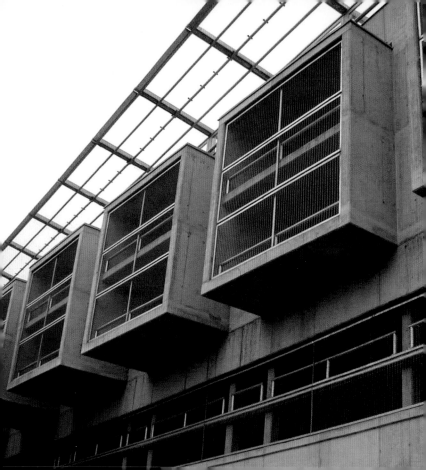

U-Bahn-Station Simmering

Subway Station

Architektengruppe U-Bahn
Tecton Consult Bauwesen – ZT-GesmbH (SE)

2003
Simmering
11. Bezirk

www.wienerlinien.at
www.agu.at

Nach zehnjähriger Planungs- und Bauzeit wurde zur Jahrtausendwende die Verlängerung der Linie U3 eingeweiht. Das Eingangsbauwerk der Station Simmering mit seinem Tragwerk aus stählernen Fachwerkbögen weckt Assoziationen an historische Bahnhofsarchitektur.

After a decade of planning and construction, the extension of the U3 subway line was opened at the turn of the century. The entrance to Simmering station, with its main structure of beams and arches made of steel, is reminiscent of historic station architecture.

Après dix années de conception et travaux, la prolongation de la ligne 3 du métro a été inaugurée en l'an 2000. Le bâtiment d'entrée de la station Simmering évoque avec ses constructions portantes de voûtes en poutres métalliques l'architecture de gare traditionnelle.

Tras un período de proyecto y construcción de diez años fue inaugurada la prolongación de la línea de metro U3 al cambiar el milenio. La edificación de entrada a la estación Simmering, con sus alas en arcos de entramado de acero, despierta asociaciones con la arquitectura histórica de estaciones.

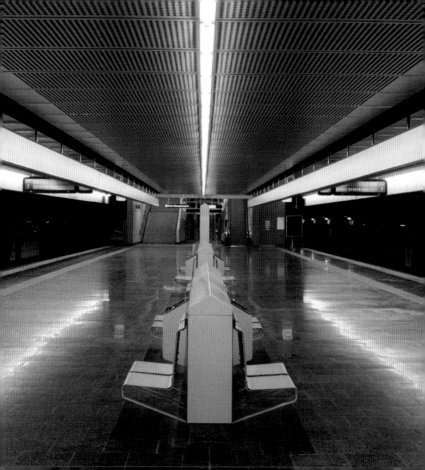

VIE Parkhaus

Car Park

Atelier Hayde Architekten
Vasko + Partner (SE)

2000
Flughafen

www.viennaairport.com
www.hayde.at

Das größte Parkhaus Österreichs beherbergt knapp 2400 Stellplätze, einen Busbahnhof im Erdgeschoss und eine Mietwagengarage im Untergeschoss. Durch offene Treppenhäuser mit Lufträumen über mehrere Geschosse ist der Bau sehr übersichtlich, so dass der Besucher sich auch nachts relativ sicher fühlen kann.

Austria's largest car park has about 2,400 parking spaces, a bus station on the ground floor and a car hire depot on the lower ground level. With open stairwells and open spaces on several levels, the building is clearly visible from all directions and visitors also feel relatively safe at night.

Le plus grand parc de stationnement d'Autriche abrite un parking d'à peine 2400 places, une gare routière au rez-de-chaussée et un garage de voitures de locations au sous-sol. Avec des cages d'escalier ouvertes sur plusieurs étages, le bâtiment est très bien agencé ce qui fait que le visiteur peut se sentir relativement en sécurité de jour comme de nuit.

El mayor parking de Austria aloja 2400 plazas, una estación de autobuses en la planta baja y un garaje de vehículos de alquiler en la planta baja. La edificación es muy abarcable por las escaleras abiertas con espacios de aire a través de varias plantas de manera que el visitante puede sentirse relativamente seguro también por la noche.

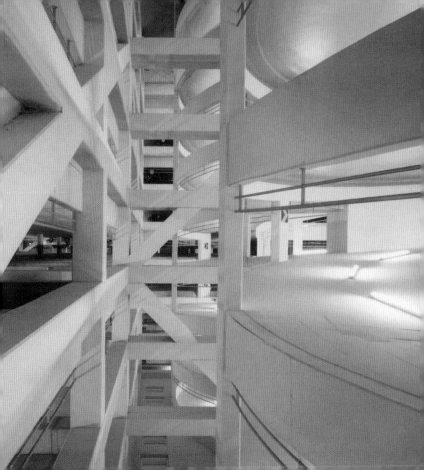

VIE Skylink

Baumschlager Eberle
Gartenmann Raab GmbH,
Itten + Brechbühl AG

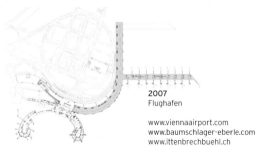

2007
Flughafen

www.viennaairport.com
www.baumschlager-eberle.com
www.ittenbrechbuehl.ch

Für den Flughafen Wien, bisher ein relativ unübersichtliches Konglomerat unterschiedlicher Bauten, entwickelten die Architekten einen Gesamtplan. Zwei Großformen, eine Sichel und ein Ring integrieren bestehende Gebäude und schaffen eine erkennbare Ordnung, die auch die Orientierung erleichtern soll.

Architects developed a master plan for Vienna's airport, which used to be a relatively confusing, dense group of different buildings. Two large forms, a sickle and a ring, join the existing buildings together and create an ordered environment, which is also intended to simplify orientation.

Pour l'aéroport de Vienne, q était jusqu'à maintenant u assemblage relativement con pliqué de différents bâtiment les architectes ont travaillé s le plan d'ensemble. Deux gran des formes, une en croissa et l'autre en anneau intègre les bâtiments déjà existants créent une structure qui doit aus si faciliter l'orientation.

Para el aeropuerto de Viena, hasta ahora un conglomerado de edificaciones diferentes relativamente poco abarcable, los arquitectos desarrollaron un plan global. Dos formas de gran tamaño, una hoz y un aro integran los edificios existentes y crean un orden perceptible que también ha de facilitar la orientación.

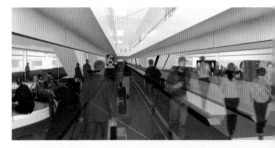

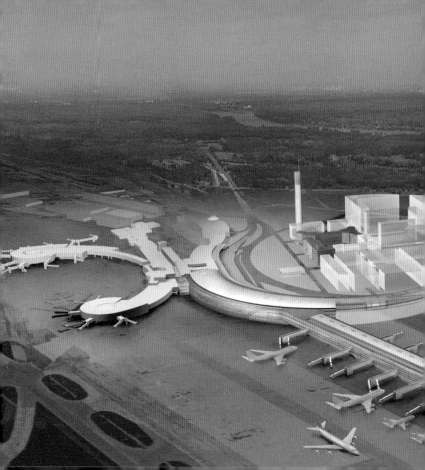

Loisium
Visitors' Center

Steven Holl Architects,
Arge Architekten Franz Sam/
Irene Ott-Reinisch

2003
Loisiumallee 1
Langenlois

www.loisium.at
www.stevenholl.com
www.samottreinisch.at

In Langenlois entstand ein Wein-Erlebnis-Center mit Laden und Gastronomie. Mitten in den Weinbergen, über einem System von Winzerkellern, die teils 900 Jahre alt sind, errichtete der Architekt einen Aufsehen erregenden Baukörper mit plastisch ausgeformter Fassade und tief eingeschnittenen Lichtschlitzen.

A wine experience center with shop and restaurant facilities was created in Langenlois. The architect built a structure in the middle of the vineyards, which attracted lots of attention. The new facilities are also above a system of wine cellars, some of which are 900 years old. The new building has a plastic, sculptured façade and deep-set light shafts.

On a créé à Langenlois un centre vinicole comprenant des magasins et des restaurants. Au milieu du vignoble, l'architecte a érigé, sur un ensemble de caves de vignerons, dont certaines sont vieilles de 900 ans, un bâtiment spectaculaire avec une façade en plastique moulé et des ouvertures en fentes profondes.

En Langenlois surgió un centro para eventos del vino con tienda y gastronomía. En medio de los viñedos, a través de un sistema de bodegas de viticultores que en parte tienen 900 años de antigüedad, el arquitecto erigió un cuerpo arquitectónico con una fachada moldeada en plástico y ranuras para la luz cortadas profundamente.

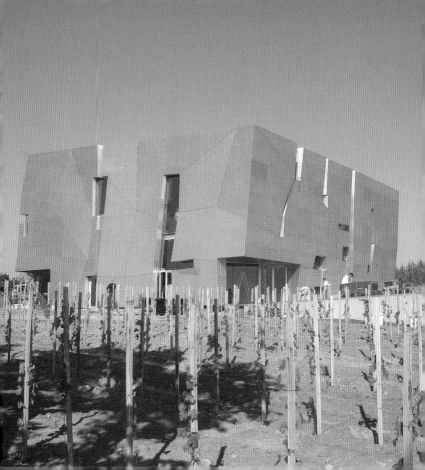

to stay . hotels

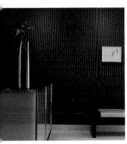 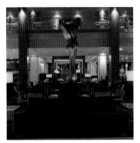 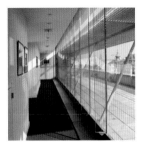

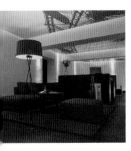 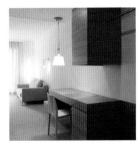 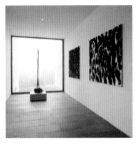

Hollmann Beletage

Christian Prasser

2003
Köllnerhofgasse 6
1. Bezirk

www.hollmann-beletage.at
www.cp-architektur.com

Neun Zimmer vermietet die kleine Pension im Herzen Wiens. Dunkelbraunes Parkett, orangerote Lampenschirme, ein offener Kamin und ein Klavier vermitteln Wohnlichkeit, ohne auf Historisierendes zu setzen. Eine grafisch abstrahierte Detailansicht des Wiener Riesenrads ziert die Textilbespannung der Decke.

The small guesthouse in the heart of Vienna has nine rooms. Dark brown parquet flooring, orange and red lampshades, an open fire and piano suggest comfort, without overemphasizing the historical element. A detail from a view of Vienna's Ferris wheel, which is an abstract, graphic print on textile, decorates the ceiling.

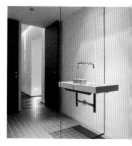

La petite pension située dans le cœur de Vienne propose neuf chambres. Les lieux, sans miser sur leur historique, offrent un espace confortable avec un parquet brun foncé, des abats-jour rouge orangé, une cheminée ouverte et un piano. Le tissu tendu au plafond est décoré d'un motif représentant un détail stylisé de la grande roue de Vienne.

Nueve habitaciones alquila la pequeña pensión en el corazón de Viena. El parquet marrón oscuro, las pantallas de las lámparas en rojo anaranjado, una chimenea abierta y un piano comunican comodidad sin apostar por lo historizante. Un detalle parcial de la noria gigante vienesa abstraído gráficamente adorna el revestimiento textil del techo.

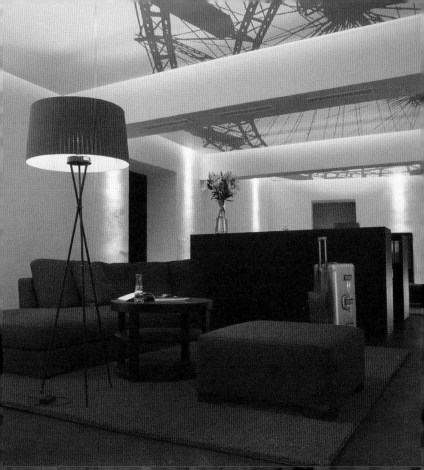

Le Meridien

Manfred Wehdorn, Fritz Schwaighofer
Yvonne Golds – Real Studios Limited (Interior)

2003
Opernring 13-15
1. Bezirk

www.lemeridien-vienna.com
www.wehdorn.at
www.realstudios.co.uk

In einen alten Prachtbau direkt an der Ringstraße, unweit von Oper und Hofburg, zog das Le Meridien ein. Doch die Innenarchitektur ist kompromisslos modern. Ein besonderes Highlight: der farbig gestaltete Pool. 294 Zimmer erwarten die Gäste.

Le Meridien moved into an old, regal building directly on Vienna's Ring, not far from the Opera House and Imperial Palace. But the interior architecture is uncompromisingly modern. A special highlight is the colorfully decorated pool. Guests are accommodated in the hotel's 294 rooms.

Le Méridien est installé dans un ancien palais, directement sur la Ringstraße à proximité de l'Opéra et du Hofburg. L'architecture intérieure est cependant résolument moderne. Une attraction particulière : le design tout en couleurs de la piscine. 294 chambres accueillent les clients.

En una fastuosa edificación antigua directamente en la Ringstraße, no lejos de la Ópera y del Hofburg, se instaló Le Meridien. Pero la arquitectura interior es moderna sin compromisos. Un punto culminante especial: la piscina creada en color. 294 habitaciones esperan a sus clientes.

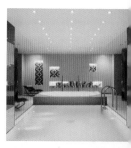

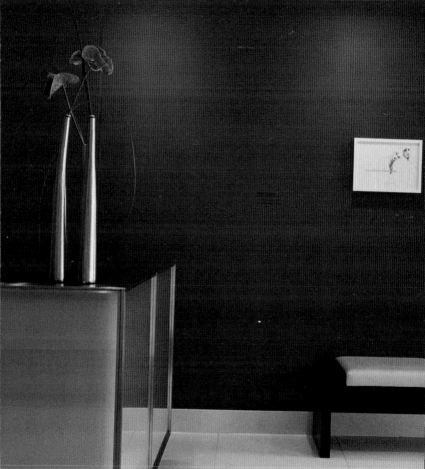

Hilton Hotel

Hans Hollein Architekt
IDM interior design management GmbH

2004
Am Stadtpark
3. Bezirk

www.hilton.de/wien
www.hollein.com
www.idm-gmbh.at

Wegen der Lage des Hotels direkt am Stadtpark bieten viele Räume einen Blick ins Grüne. 2004 wurde das Gebäude von Grund auf renoviert. Seine 579 Zimmer und Suiten sind zeitlos elegant eingerichtet, cremige Töne sollen für Behaglichkeit sorgen.

Many rooms have a rural outlook due to the hotel's location directly on the city's park. In 2004, the building was completely renovated. The 579 rooms and suites have been elegantly furnished to give a timeless atmosphere, which is enhanced by cream tones for comfort.

De part sa situation au bord du parc de la ville, l'hôtel propose beaucoup de salles avec vue sur la verdure. Le bâtiment a été complètement rénové en 2004. Ses 579 chambres et suites sont aménagées avec une élégance intemporelle, les tons crème contribuent à créer un espace agréable.

Debido a la situación del hotel directamente en el parque municipal muchas habitaciones ofrecen vistas a la zona verde. En 2004, el edificio fue reformado totalmente. Sus 579 habitaciones y suites están equipadas con una elegancia intemporal, los tonos crema han de procurar comodidad.

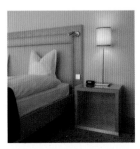
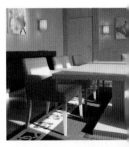

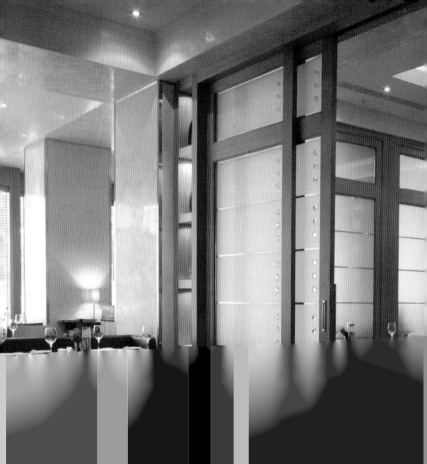

Das Triest

Peter Lorenz Architekt + Partner, Manfred König
Terence Conran (Interior)

1995
Wiedner Hauptstraße 12
4. Bezirk

www.dastriest.at
www.peterlorenz.at
www.conranandpartners.com

Der über 300 Jahre alte Bau diente früher als Bahnhof für Postkutschen, bevor in den Kreuzgewölben Salons und Suiten untergebracht wurden. Eine Aufstockung setzt sich durch eine Glasfuge vom Bestand ab und geht mit ihrer Fassadengliederung auf die horizontalen Linien des Altbaus mit seinen Gesimsen ein.

Before it housed the salons and suites in the cloisters, this building, which is over 300 years old, used to be a station for the post stagecoaches. A glass groove distinguishes the extension of the upper floors from the existing building and the design of its façade matches the horizontal lines of the older building with its cornices.

Le bâtiment, qui a plus de 300 ans, servait autrefois de gare de diligences, avant que des salons et des suites ne soient aménagés dans cet espace au voûtes croisées. Un élément en verre déjà existant fait la transition entre le bâtiment existant et la surélévation, qui s'accorde de part la structure de sa façade à la ligne horizontale des corniches de l'ancien bâtiment.

La edificación, de una antigüedad de más de 300 años, sirvió primeramente de estación de coches de correos, antes de que en las bóvedas de crucería se alojaran salones y suites. Una sobreedificación se destaca de lo existente por medio de una junta de vidrio correspondiendo con la estructura de su fachada a las líneas horizontales del edificio antiguo con sus cornisas.

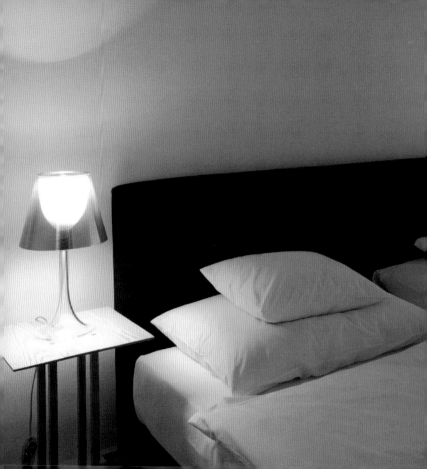

Hanner

pla.net

2003
Mayerling 1
Mayerling

www.hanner.cc
www.architects-pla.net

Der Bau am Wienerwald will Architektur, Landschaft und Kunst verbinden. Er greift die Materialien der Umgebung – Holz und Stein – auf und schafft mit großen, von Mauerscheiben durchstoßenen Glasflächen einen fließenden Übergang von innen nach außen. Zeitgenössische Kunst findet sich in allen Räumen.

The building in the Vienna Woods is intended to integrate architecture with landscape and art. It adopts the materials of the surroundings, i.e. wood and stone, and forms a flexible transition from inside to outside with large glass areas, which are interrupted by sections of masonry. Contemporary art decorates all of the rooms.

Ce bâtiment au bord de la Wiener wald, région boisée à l'ouest de Vienne, veut conjuguer architecture, paysage et art. Il reprend les matériaux environnants, le bois et la pierre, et crée avec de grandes baies vitrées transpercées de parties maçonnées un passage fluide de l'intérieur vers l'extérieur. On peut trouver des œuvres d'art contemporain dans chaque pièce.

La edificación en el bosque vienés quiere unir arquitectura, paisaje y arte. Recurre a los materiales del entorno –madera y piedra– y crea, con superficies acristaladas penetradas por discos de muro una transición fluida desde el interior hacia el exterior. El arte contemporáneo se encuentra en todas las salas.

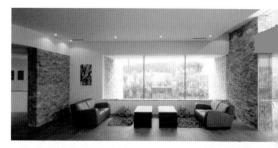

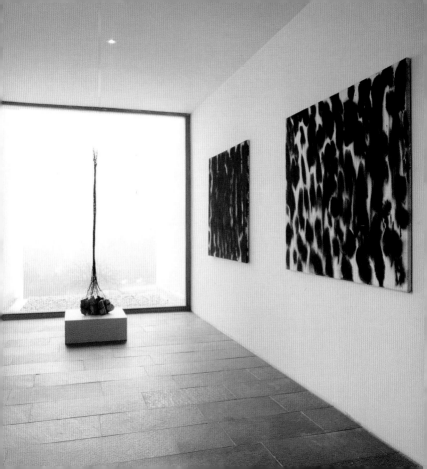

Loisium Hotel

Steven Holl Architects, Arge Archiktekten Franz Sam/
Irene Ott-Reinisch

2005
Loisiumallee 1
Langenlois

www.loisium.at
www.stevenholl.com
www.samottreinisch.at

60 Minuten westlich von Wien, inmitten von Weinbergen, liegt das Hotel mit Restaurant, Konferenzräumen, Spa und 82 Gästezimmern. Die u-förmige Anlage bildet einen Hof. Ein zweigeschossiger Riegel scheint über der transparenten Erdgeschosszone zu schweben. Das Hotel ist Teil eines Wein-Erlebniscenters.

The hotel with a restaurant, conference rooms, spa and 82 rooms is located 60 minutes west of Vienna, surrounded by vineyards. The U-shaped site forms a courtyard. A two-storey complex seems to be suspended over a transparent lower level. The hotel is part of a wine experience center.

C'est à 60 minutes à l'ouest de Vienne, au milieu du vignoble que se trouve l'hôtel avec son restaurant, ses salles de conférence, des thermes et 82 chambres. L'ensemble en U forme une cour. Une barre de deux étages semble flotter au dessus du rez-de-chaussée transparent. L'hôtel fait partie du centre vinicole.

60 minutos al oeste de Viena, en medio de los viñedos, se halla el hotel con restaurante, salas de conferencias, spas y 82 dormitorios. El recinto en forma de U forma un patio. Un cuerpo alargado de dos plantas parece estar suspendido sobre la zona transparente de la planta baja. El hotel es parte de un centro para eventos del vino.

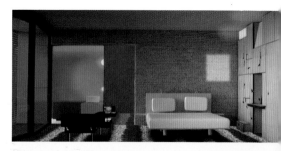

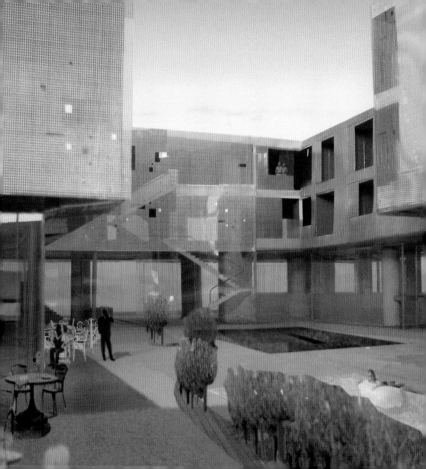

to go . eating
drinking
clubbing
wellness, beauty & sport

 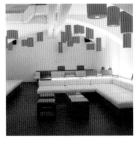

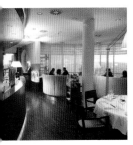 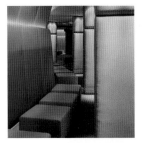

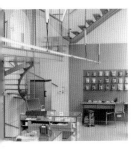 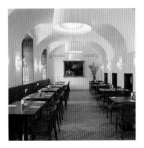 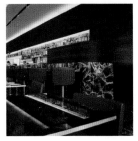

Club Babenberger Passage

Söhne & Partner

2003
Babenberger Straße /
Burgring
1. Bezirk

www.sunshine.at
www.soehnepartner.com

Was einst eine Unterführung aus den 60er Jahren war, ist nun ein Club. Die ehemaligen Abgänge wurden mit hinterleuchteten transluzenten Glaskuben geschlossen, die dem Club Präsenz auf der Straße verleihen. Das DJ-Pult und zwei der Cocktailbars sind beweglich – zwecks maximaler Nutzungsflexibilität.

What used to be a 1960s subway is now a nightclub. The old exits were sealed with translucent, glass cubes and rear lighting, in order to make the club visible on the street. The DJ's turntable and two of the cocktail bars are mobile, giving maximum flexibility for different uses.

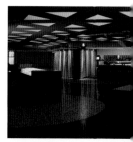

Ce qui a été un passage souterrain dans les années soixante est maintenant un club. Les anciennes sorties ont été fermées par des cubes de verre translucides éclairés par l'arrière, qui signalent la présence du club sur la rue. La console du DJ et deux des bars à cocktail sont amovibles pour permettre une flexibilité maximale dans l'utilisation.

Lo que una vez fue un paso subterráneo surgido en los años 60 es ahora un club. Las antiguas salidas fueron cerradas con cubos de vidrio translúcidos iluminados por la parte de atrás los cuales dotan al club de presencia en la calle. El púlpito para el discjockey y dos de los bares de cócteles son móviles con el objetivo de la máxima flexibilidad en su utilización.

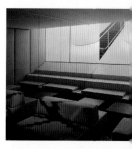

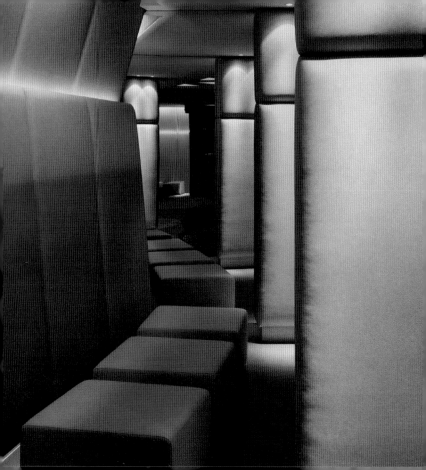

Café Atelier

Hans Hollein Architekt

2004
Albertinaplatz 1
1. Bezirk

www.albertina.at
www.hollein.com

Das Café befindet sich in einem ehemaligen Hohlraum zwischen den Gemäuern der Albertina, der mit Trümmern aus dem Zweiten Weltkrieg aufgefüllt war. Nach dem Freiräumen wurden die Fundamente sichtbar, die nun als rauhe Ziegelwand einen Kontrast zu den glatten weichen Materialien der Einrichtung bilden.

The café is located in what used to be an empty space, situated next to the outer walls of the Albertina, and filled with rubble from the Second World War. After the discovery of this hollow space, the foundations became visible and they are now exposed as a rough brick wall to contrast with the smooth and soft materials of the café's interior.

Le café se trouve entre les murailles de l'Albertina dans un ancien espace vide, qui avait été comblé avec des décombres de la Deuxième Guerre mondiale. Après que l'espace ait été dégagé, les murs de fondations sont devenus visibles et leur maçonnerie de briques grossière forme maintenant un contraste avec les matériaux délicats et lisses de l'aménagement.

El café se encuentra en un antiguo hueco entre los muros de la Albertina que había sido llenado con escombros de la Segunda Guerra Mundial. Después de retirarlos aparecieron los fundamentos que, ahora como una áspera pared de ladrillos, forman un contraste con los suaves materiales planos del establecimiento.

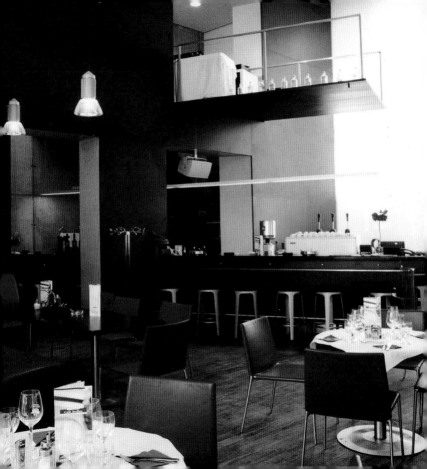

Yellow

BEHF Architekten

2004
Mariahilfer Straße 127
6. Bezirk

www.yellow.co.at
www.behf.at

Die Räumlichkeiten teilen sich in einen Restaurant- und einen Barbereich, die durch eine durchquerbare Küche verbunden werden. Mit großflächigen, verschiebbaren Wandelementen und kleineren auf- und zuklappbaren Lichtnischen lassen sich immer wieder unterschiedliche Stimmungen schaffen.

The rooms divide into a restaurant and a bar area, which can be accessed by walking through the kitchen. Different atmospheres can constantly be created, by repositioning mobile, large partition walls and adjusting smaller lighting niches, which can be open or shut.

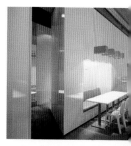

Les lieux sont composés d'un restaurant et d'un bar qui sont reliés par une cuisine qu'on peut traverser de part en part. De grandes cloisons murales amovibles et des niches lumineuses plus petites, qu'on peut ouvrir et fermer, permettent de créer des ambiances toujours différentes.

Las salas se dividen en una zona de restaurante y una de bar unidas por una cocina que puede atravesarse. Con elementos del muro amplios y desplazables y nichos de luz más pequeños que se abren y se cierran pueden crearse diferentes ambientes una y otra vez.

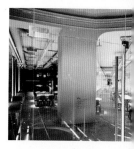

Naschmarkt Deli

Dietrich | Untertrifaller Architekten

2001
Naschmarkt / Stand 421-436
6. Bezirk

www.naschmarkt-deli.at
www.dietrich.untertrifaller.com

Die Stände auf dem Naschmarkt im Herzen Wiens folgen einem einheitlichen Typus und dürfen kaum verändert werden. Bei der Umnutzung eines Standes zu einem Restaurant versuchten die Architekten, das Marktambiente zu wahren. Der Boden aus Bitumen und Steinmehl entspricht dem umliegenden Gehwegbelag.

The stalls on Vienna's Naschmarkt in the heart of the city conform to a standard, from which it is not really possible to deviate. The project of turning one of the market stalls into a restaurant led architects to try and preserve the marketplace ambiance. The bitumen and grit flooring retains elements of the surface material for the surrounding pedestrian area.

Les stands du marché « Naschmarkt », situé au cœur de Vienne sont tous construits sur le même modèle et ne peuvent presque pas subir de changements. Lors de la transformation d'un stand en restaurant, les architectes ont essayé de préserver l'ambiance du marché. Le sol en bitume et poudre de grés rappelle le revêtement des allées environnantes.

Los puestos en el Naschmarkt en el corazón de Viena siguen un tipo unitario y apenas está permitida su modificación. Para la reutilización de un puesto en un restaurante los arquitectos intentaron conservar el ambiente del mercado. El suelo de bitumen y piedra molida corresponde al pavimento de las vías vecinas.

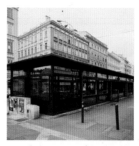

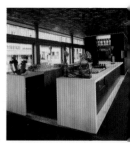

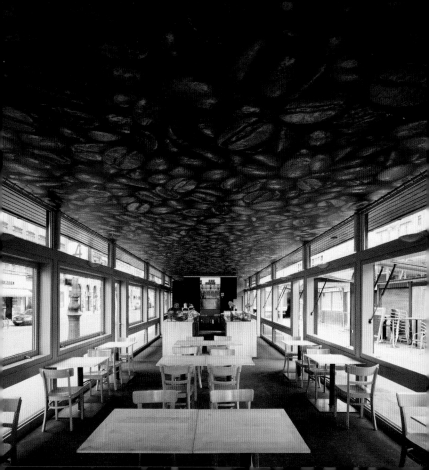

Café-Restaurant Una

Lacaton & Vassal

2001
Museumsplatz 1
7. Bezirk

www.azw.at

Im Hof des MuseumsQuartiers liegt das Architekturzentrum Wien, zu dem auch ein Café gehört. Der hohe, überwölbte Raum wurde mit farbigen Stühlen, Holztischen und einer strengen schwarzen Theke möbliert. Die unverputzte Trennwand zur Küche verweist auf den Prozess des Bauens.

Vienna's architectural center is located in the courtyard of the MuseumQuartier that also includes a café. The height of the space that is covered by a series of arches was furnished with colorful chairs, wooden tables and a rigorous, black bar area. The exposed-brick dividing wall between the kitchen and the café hints at the construction process.

Dans la cour du Museums-Quartier se trouve le Centre d'architecture de Vienne qui abrite aussi un café. La pièce haute et voûtée a été meublée de sièges colorés, de tables en bois et d'un meuble de bar noir et strict. Le mur de séparation avec la cuisine avec son aspect brut renvoie au procédé de construction.

En el patio del Barrio de los Museos (MuseumsQuartier) se encuentra el Centro de Arquitectura de Viena al cual también pertenece un café. La sala, alta y abovedada, fue amueblada con sillas de colores, mesas de madera y un austero mostrador negro. La pared de separación hacia la cocina, no revocada, remite al proceso de construcción.

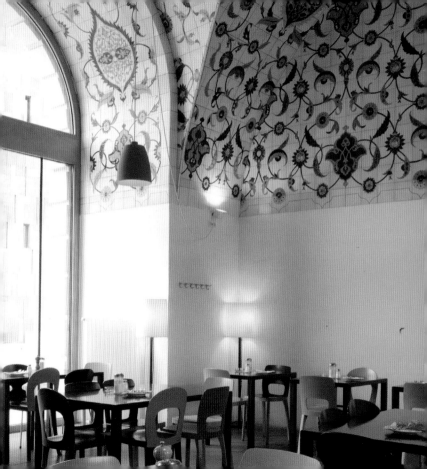

ra'an

Dong Ngo, Sophie Esslinger, Jun Yang

2003
Währinger Straße 6-8
9. Bezirk

www.raan.at

Das großzügig angelegte Lokal erstreckt sich auf 500 Quadratmetern über drei Stockwerke. Während es tagsüber als Café und Take-away fungiert, kommt der Gast abends in den Genuss von Cocktails und Musik. Die Einrichtung wirkt unverkrampft, verspielt und heiter.

This spacious bar has three different levels and takes up 500 square meters. In the daytime it is a café and takeaway and in the evening clients can enjoy cocktails and music. The interior is relaxed, playful and lively.

Ce vaste établissement est aménagé sur 500 mètres carré sur trois étages. Alors que le jour, ce lieu fait office de café et propose des plats à emporter, la clientèle peut le soir y déguster des cocktails et écouter de la musique. L'aménagement est peu conventionnel, amusant et gai.

El local, dispuesto ampliamente, se extiende 500 metros cuadrados a través de tres plantas. Mientras que durante el día funciona como café y take away, por la noche el cliente disfruta del consumo de cócteles y música. El establecimiento produce un efecto relajado, juguetón y alegre.

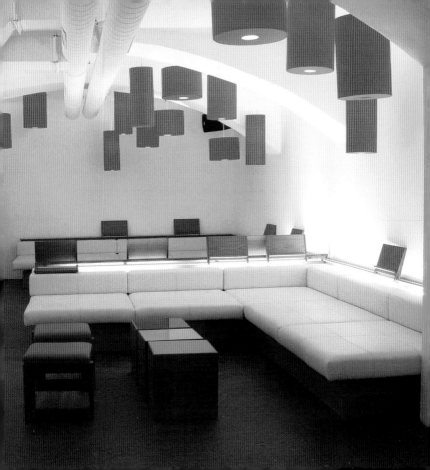

Ruben's Brasserie

Christoph Huber

2003
Fürstengasse 1
9. Bezirk

www.rubens.at

Ein Barockgebäude erhielt eine gastronomische Nutzung. Wandverkleidungen aus glatt geschliffenem Nussholz, ein Eichenboden und lange, mit braunem Leder bezogene Sitzbänke verleihen der Brasserie ein gediegenes Flair, während der Weinkeller dank des roh belassenen Gewölbes und Bodens rustikaler wirkt.

This baroque building was turned into a restaurant facility. The walls are made of highly polished, planed nut-wood, the flooring is oak and the long benches have brown, leather covering. These elements give the brasserie a distinguished flair, while the wine cellar has a more rustic look, thanks to the cellar's rougher arches and the floor.

Un bâtiment baroque a été détourné à des fins gastronomiques. Le revêtement des murs en noyer finement poncé, des sols en chêne et de longues banquettes de cuir brun confèrent à la brasserie un flair de bon aloi, tandis que la cave à vin avec sa voûte et son sol restés à l'état brut, paraît plus rustique.

Un edificio barroco recibió una utilización gastronómica. Los revestimientos de las paredes de madera de nogal lisamente pulida, un suelo de madera de roble y los bancos alargados forrados de cuero marrón dotan a la brasería de un sólido encanto mientras que la bodega –gracias a la bóveda y al suelo mantenidos en estado natural– produce una impresión rústica.

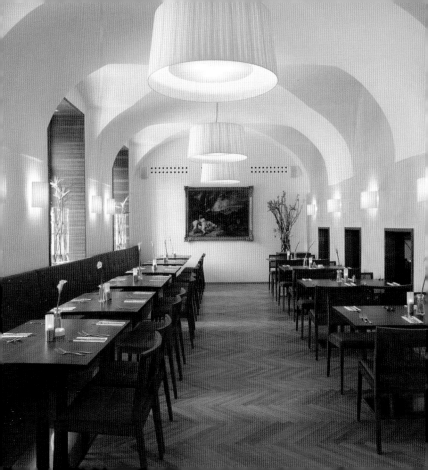

Wrenkh Restaurant & Bar

Eichinger oder Knechtl

2003
Bauernmarkt 10
1. Bezirk

www.wrenkh.at
www.eok.at

Bekannt wurde das Wrenkh durch seine vegetarische Küche. Inzwischen bietet das Restaurant aber auch Fleisch und Fisch an, und anlässlich dieses Wechsels wurde auch die Einrichtung erneuert. Die Wände im hinteren Teil wurden heller gestrichen, der Raum wirkt – analog zu den Speisen – leicht.

The Wrenkh made a name for itself with its vegetarian cooking. Now, however, the restaurant also serves meat and fish dishes and to mark this change of culinary style, the interior was also freshened up. At the rear of the restaurant, the walls were painted lighter and the space has a light effect—just like the food.

Le Wrenkh était connu par sa cuisine végétarienne. Entre temps il propose aussi du poisson et de la viande et c'est à l'occasion de ce changement que l'aménagement a été renouvelé. Les murs du fond ont été peints de couleur claire, l'espace paraît léger, comme les plats qu'on peut y déguster.

El Wrenkh fue conocido por su cocina vegetariana. Pero entretanto, el restaurante también ofrece carne y pescado y, con motivo de este cambio, las instalaciones también fueron renovadas. Las paredes en la parte de atrás se pintaron más claras, el espacio aparece –análogamente a las comidas– ligero.

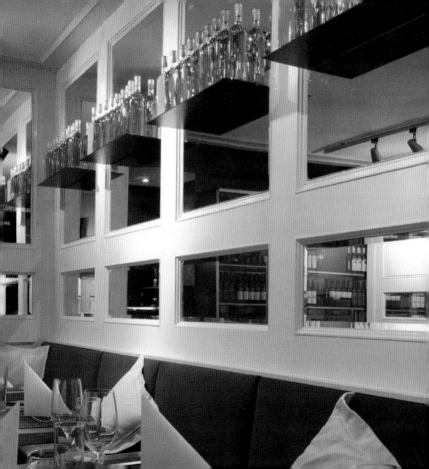

Brunners

Atelier Heiss

2002
Wienerbergstraße 7
10. Bezirk

www.brunners.at
www.atelier-heiss.at

In einer Hochhausspitze untergebracht, bieten das Restaurant und die Bar einen Panoramablick über das Stadtzentrum und die Donaucity. Eigenwillig ist die Präsentation der Weine: Die Flaschen liegen in einer Reihe auf einem Glasregal unter der Decke und wirken, als ob sie dort entlang fliegen würden.

The restaurant and bar are located at the top of this high-rise building and have a panoramic view over the city center and Danube City. The wine presentation is rather quirky: bottles are lying in a row on a glass shelf under the ceiling and they look as if they are flying past.

Logé au sommet d'une tour, le restaurant et le bar offrent une vue panoramique sur le centre ville et la Donau-city. La présentation du vin est originale : les bouteilles sont alignées sur des étagères en verre sous le plafond et cela donne l'impression qu'elles planent le long de la surface.

Alojados en la cumbre de un rascacielos, el restaurante y el bar ofrecen una vista panorámica del centro de la ciudad y de la Donaucity. Original es la presentación de los vinos: Las botellas están en una hilera sobre una estantería de cristal debajo del techo y parece como si allí estuviesen volando a lo largo de ella.

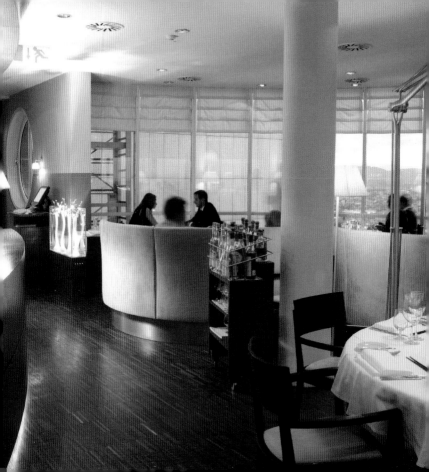

Café Gloriette

Architekturbüro Ullmann + Ebner
Barbara Mayr (SE)

1998
Schloss Schönbrunn
13. Bezirk

www.gloriette-cafe.at

In die Gloriette, 1775 im Schlosspark von Schönbrunn errichtet, ist ein Café eingezogen, dessen Innenarchitektur dem Denkmal Respekt zollt. Sie betont das Temporäre des Eingriffs durch die Wahl des Materials: Selbst die wenigen fest installierten Elemente aus hellem Ahorn wirken wie verschiebbare Möbel.

Dans la Gloriette, qui a été érigée en 1775 dans le parc du palais de Schönbrunn, on a aménagé un café dont l'architecture intérieure respecte le monument. Le choix des matériaux met l'accent sur l'aspect temporaire de l'intervention : même les quelques éléments fixes en érable clair qui s'y trouvent, ont l'air de meubles amovibles.

A café has moved into the Gloriette, located in the parklands of Schönbrunn Palace and built in 1775. The café's interior pays respect to the monument and emphasizes its temporary intrusion by the selection of material: even the few pieces of furniture that have been permanently installed are made out of light maple. They look as though they can easily be moved.

En el Gloriette, erigido en 1775 en el parque del Palacio de Schönbrunn, se instaló un café cuya arquitectura interior expresa respeto al monumento y acentúa lo temporal de la intervención por medio de la elección del material: Incluso los pocos elementos instalados de forma fija, de arce claro, parecen muebles desplazables.

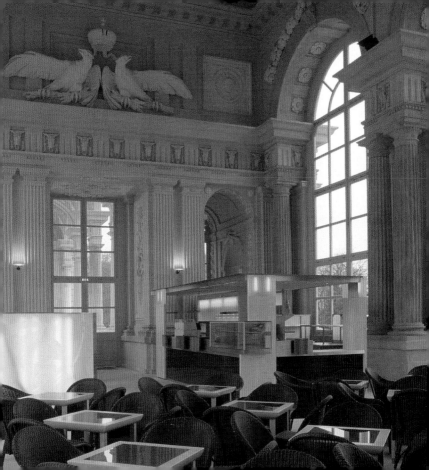

Yume

BEHF Architekten

2002
Bergmillergasse 3
14. Bezirk

www.yume.at
www.behf.at

Ein japanisches Restaurant mit sehr reduzierter Innenarchitektur: Die Farben Schwarz und Weiß dominieren, strenge Sehschlitze an der Fassade gestatten nur gezielte Ein- und Ausblicke. Die offene Küche steht in der Mitte des Raumes, das Kochen ist Mittelpunkt des gastronomischen Erlebnisses.

A Japanese restaurant with minimalist interior design: black and white as predominant colors; strict window-slits in the façade permit only well-directed views from inside and outside. The open-plan kitchen is in the middle of the room and the chef's activity is the focus of the gastronomic experience.

Un restaurant japonais avec une architecture intérieure très dépouillée : le noir et blanc dominent, des fentes très strictes sur la façade ne permettent qu'une vue réduite vers l'extérieur comme vers l'intérieur. La cuisine ouverte se tient au milieu de l'espace, faire la cuisine est l'élément central de l'expérience gastronomique.

Un restaurante japonés con una arquitectura interior muy reducida: Dominan los colores negro y blanco, las austeras aberturas visuales en la fachada permiten solamente miradas precisas hacia dentro y hacia afuera. La cocina abierta se encuentra en el medio de la sala, cocinar es el centro de la experiencia gastronómica.

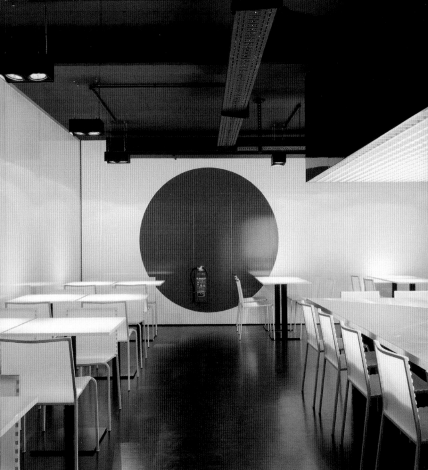

Frisuersalon Markus Herold

Hairdresser

gaupenraub+/-

2000
Stoß im Himmel 1
1. Bezirk

www.gaupenraub.net

Ein horizontales Band von 38 Metern Länge windet sich durch den Raum, umschlingt Pfeiler, bildet mal ein Zeitschriftenregal, mal einen Shampoomischplatz, mal einen Handtuchschrank und nimmt Spiegel, Ablagefläche, Fußstütze, Beleuchtung und Musikanlage auf. Es ist mit Edelstahl und Polyester verkleidet.

A horizontal strip of 124 feet in length winds its way through the salon, curving around pillars, occasionally forming a magazine rack or a shampoo area, or a shelf for towels and integrating mirrors, work surfaces, foot rests, lighting and a stereo. It has a stainless steel and polyester finish.

Une bande horizontale de 38 mètres de long se déploie à travers la pièce, enlace les piliers forme ici une étagère à maga zines, là un endroit pour faire les shampooings, là encore une armoire pour les serviettes et en globe miroirs, tablettes, repose pieds, éclairages et la chaîne sté réo. Cette bande est recouverte de d'acier et de polyester.

Una banda horizontal de 38 metros de longitud serpentea por la sala, envuelve pilares, forma aquí un estante para revistas, allí un lugar de mezclas de champús, allá un armario para toallas y acoge espejos, superficies para depositar objetos, apoyos para los pies, la iluminación y la instalación de música. Está revestido de acero inoxidable y de poliéster.

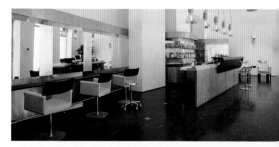

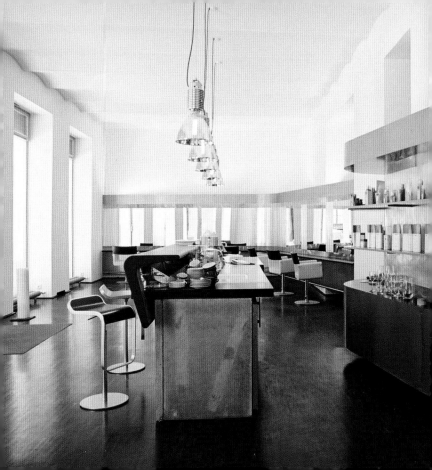

Entertainmentcenter Gasometer Pleasuredome

Rüdiger Lainer

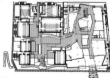

2001
Guglgasse 43
11. Bezirk

www.wiener-gasometer.at
www.lainer.at

In unmittelbarer Nachbarschaft der bekannten, umgenutzten Gasometer entstand ein Kinocenter. Intensiv gefärbte Fensterscheiben vor der eigentlichen Glasfassade bilden einen Luftraum als thermischen Puffer und tauchen tagsüber die Foyerzonen, nachts den Außenraum in stimmungsvolles Licht.

A cinema complex was built in the vicinity of the well-known and derelict gasometers. Vividly colored window panes in front of the actual glass frontage form an open space that serves as a layer of insulation. During the day, the foyer areas and, at night, the outside areas are bathed in atmospheric light.

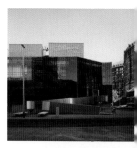

Dans le voisinage immédiat du célèbre gazomètre qui a été réaménagé, un complexe de salles de cinéma a vu le jour. Des vitres aux couleurs intensives ont été placées devant de la façade, elle-même en verre, et forment ainsi un espace tampon isolant. Tandis que pendant la journée ce sont les halls qui sont plongés dans une atmosphère lumineuse, la nuit c'est l'espace extérieur.

En la directa vecindad del conocido Gasómetro reutilizado surgió un centro de cines. Los escaparates coloreados intensamente, delante de la verdadera fachada de cristal, forman un espacio de aire como un amortiguador térmico y sumergen las zonas del vestíbulo, por el día, y el espacio exterior, por la noche, en una luz muy expresiva.

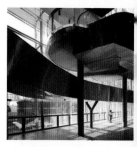

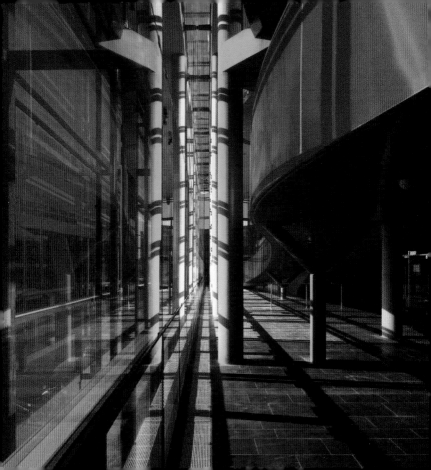

Marienapotheke

Pharmacy

Stadtgut

2000
Martinstraße 93
18. Bezirk

www.stadtgut.com

Um dem Verkaufsraum ein Maximum an Großzügigkeit zu verleihen, entfernten die Planer alle Zwischenwände und gestalteten die nötigen Einbauten möglichst transparent: Eine filigrane Treppe und Trennwände aus Glas lassen den Blick horizontal wie vertikal – etwa zur Galerieebene – schweifen.

The planners removed all partition walls and arranged the internal fittings that had to be as transparent as possible, so as to provide maximum space for the sales floor. A filigree stairway and partition walls made out of glass make it easy to cast a glance sideways or upwards, like for instance, to the gallery level.

Pour dégager au maximum l'espace de vente les concepteurs ont enlevé toutes les cloisons et ont créé dans la mesure du possible les éléments nécessaires dans des matériaux transparents : un escalier très léger et des cloisons en verre permettent au regard d'errer aussi bien horizontalement que verticalement, vers la galerie par exemple.

Para dotar al espacio de venta de un máximo de amplitud, los proyectistas retiraron todas las paredes intermedias y crearon los módulos necesarios lo más transparentes posible: Una escalera de filigrana y las paredes divisorias de vidrio dejan vagar la mirada tanto horizontal como verticalmente (por ejemplo al plano de la galería).

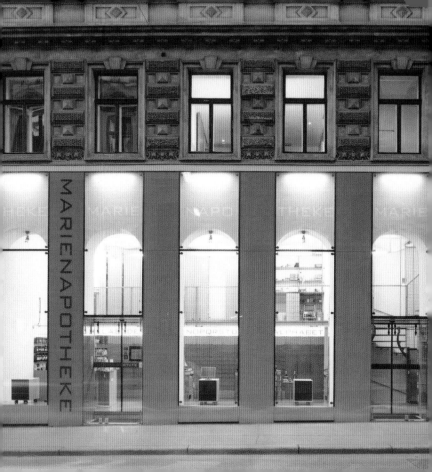

humanitas 21

Pharmacy

Stadtgut
Dipl.-Ing. Werner Westhausser (SE)

2003
Jedleseerstraße 66-94
21. Bezirk

www.stadtgut.com

Eine Apotheke als Trendboutique: An den Verkaufstresen springen gelb leuchtende Felder ins Auge, an den Pfeilern strahlen gelbe Neonröhren hinter mattiertem Glas, und in den Boden sind wellenförmige gelbe Flächen eingelassen. Die Möblierung aus grauen Eternitplatten bildet den Hintergrund.

A pharmacy as a trendy boutique: bright yellow zones grab the customer's attention at the sales counter; yellow neon strips are illuminated on pillars set behind matt glass; and yellow areas in the shape of waves are set into the floor. The backdrop is provided by display units made of grey, fibre cement plates.

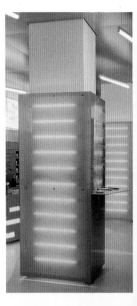

Une pharmacie aménagée comme une boutique de mode : aux comptoirs de vente, des surfaces lumineuses jaunes sautent aux yeux, sur les piliers des néons jaunes rayonnent derrière du verre mat et des surfaces ondulées jaunes sont enchâssées dans le sol. À l'arrière-plan se trouve un mobilier en plaques d'éternit grises.

Una farmacia como una boutique de tendencias: Las partes de un amarillo resplandeciente saltan a la vista en los mostradores de venta, los tubos de neón amarillos detrás del cristal esmerilado relucen en los pilares y las superficies amarillas en forma de olas están alojadas en los suelos. El fondo lo forma el mobiliario compuesto de placas grises de eternita.

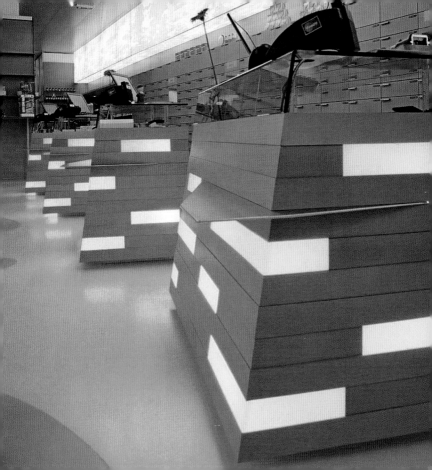

Gesundheitszentrum Wiesenstadt

Health Center

monomere

2002
Rösslergasse 1
23. Bezirk

www.monomere.at

Eine Arztpraxis in einem Laden-lokal einzurichten, erfordert be-sondere Maßnahmen: Um den Charakter als offene Anlaufstelle zu unterstreichen, wahrt ein transluzenter Screen vor der Schaufensterscheibe den visu-ellen Bezug zur Straße, bietet aber gleichzeitig den nötigen Blickschutz.

It takes something special to furnish a doctor's practice in a shopping precinct. A translucent screen in front of the practice's window maintains visual contact with the street, yet giving the cli-entele the necessary protection, while emphasizing the fact that this is a place that everyone must be able easily to access.

Un cabinet de médecin installé dans un magasin, cela exige de prendre des mesures par-ticulières : afin de souligner le caractère d'espace ouvert, un écran translucide devant la vi-trine permet à la fois de voir la rue tout en assurant la discrétion nécessaire.

Instalar una consulta médica en un local comercial requiere me-didas especiales: Una pantalla translúcida delante de la ventana del escaparate mantiene la refe-rencia visual hacia la calle para acentuar el carácter de un ser-vicio público de atención, pero ofreciendo al mismo tiempo la necesaria protección de las mi-radas.

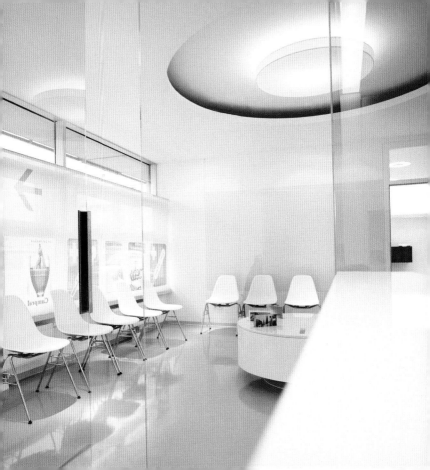

to shop . mall
retail
showrooms

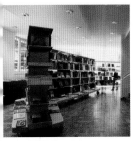
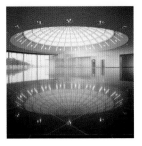
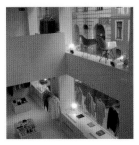
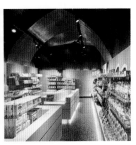
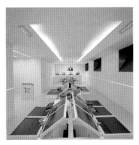
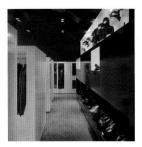
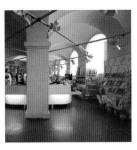
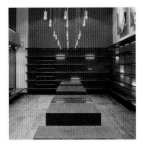
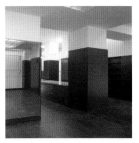

Helmut Lang

Atelier Gustav Pichelmann

1995
Seilergasse 6
1. Bezirk

www.helmutlang.com
www.pichelmann.com

Ein klassisch-streng gestaltetes Modegeschäft: Die lange Theke teilt den straßenseitigen Teil des Raums in die Bereiche für Damen- und Herrenmode. Der hintere Teil, der durch eine Glasdecke belichtet wird und beinahe leer belassen wurde, bildet die Bühne für das Anprobieren der Kleidungsstücke.

A classic and strictly ordered fashion shop: the long counter divides the part of the room, which is nearest the street, into women's and men's fashion. The rear area, which is illuminated through a glass canopy ceiling, is almost empty. This space forms a backdrop for changing rooms.

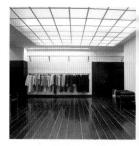

Un aménagement classique et rigoureux pour cette boutique de mode : du coté de la rue, un long comptoir partage la pièce en un espace pour les femmes et un pour les hommes. La partie arrière de la pièce, éclairée par un plafond lumineux en verre et pratiquement vide constitue un espace pour les essayages.

Una tienda de moda creada de un modo clásico y riguroso: El largo mostrador divide la parte del espacio hacia la calle en las zonas de moda para damas y caballeros. La parte trasera, que se ilumina a través de un techo de cristal y se dejó casi vacía, constituye el escenario para probar las prendas de vestir.

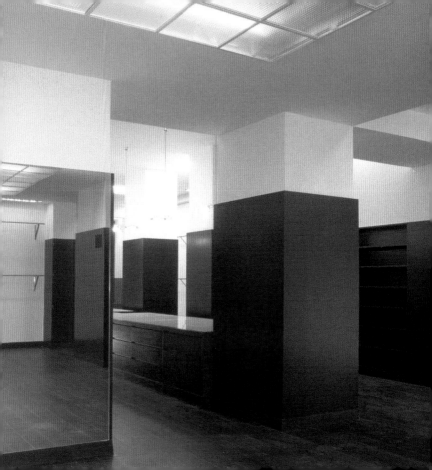

Museumsshop
Kunstforum Wien

Architekturladen

2002
Freyung 8
1. Bezirk

www.kunstforum-wien.at
www.architekturladen.at

In einen vorgefundenen Raum, der fast unverändert blieb, implantierten die Architekten ein geknicktes, rollbares Bücherregal, lang gestreckte Vitrinen und einen Kassenschalter aus Wengeholz. Verbindendes Element ist die knallgrüne Farbe der Kunstlederrahmen, welche die Verkaufsobjekte vom Raum trennt.

Architects installed a curved, mobile bookshelf, long display cases and a cash desk made of Wenge hardwood in an existing room, which was virtually kept in its original state. The bright-green color of the synthetic leather strip separating articles on sale from the room itself is the element that combines everything.

Les architectes ont aménagé dans la pièce existante, qui est restée presque intacte, une étagère à livres inclinée et roulante, de longues vitrines et un meuble en bois de Wengé pour la caisse. La couleur vert vif des châssis en cuir synthétique, tout en jouant un rôle d'élément de liaison, marque la séparation entre les objets en vente et le reste de l'espace.

En un espacio hallado, que casi quedó sin modificarse, los arquitectos implantaron una estantería plegada con ruedas, unas vitrinas que se extienden a lo largo y una taquilla hecha de madera de wengé. El elemento vinculante es el color verde chillón de los marcos de piel artificial que separa los objetos de venta de la sala.

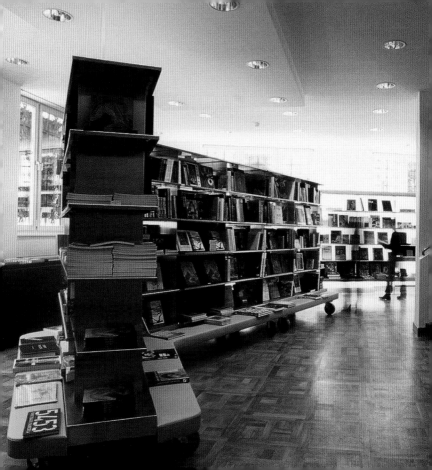

Manner

BEHF Architekten

2004
Stephansplatz 7
1. Bezirk

www.manner.com
www.behf.at

Das Geschäft eines Pralinenherstellers befindet sich in einem historischen Palais am Stephansplatz. Kleine braune Kacheln bedecken Boden, Wände und Gewölbe, so als wäre der ganze Raum mit Schokolade überzogen. Kleine Monitore, zwischen den Waren platziert, zeigen Bilder von der Produktion der Leckereien.

The store of a Viennese chocolatier is located in an historic spot on St. Stephen's Square. Small, brown tiles cover the floor, walls and arched ceilings, as if the entire space is covered in chocolate. Small screens placed amongst the goods show pictures from the production of various delicacies.

Le magasin du chocolatier se trouve dans un palais historique sur la place Stephan. De petits carreaux de faïence bruns sur le sol, les murs et les voûtes donnent l'impression que toute la pièce est recouverte de chocolat. Placés entre les produits, des écrans montrent des images qui expliquent la fabrication de ces gourmandises.

La tienda de un fabricante de bombones se encuentra en un palacio histórico en la Stephansplatz. Las pequeñas baldosas marrones cubren suelos, paredes y bóveda como si toda la sala estuviese cubierta de chocolate. Los pequeños monitores, colocados entre los productos, muestran imágenes de la producción de los dulces.

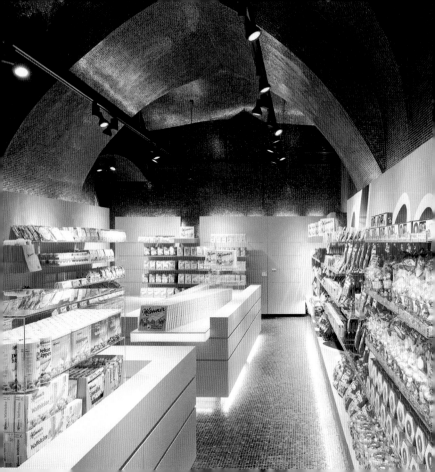

Taxxido Store

BKK - 3 ZT - GmbH

2004
Strauchgasse 1
1. Bezirk

www.tomtow.com
www.bkk-3.com

Subtile Eingriffe in die historische Fassade steigern die Präsenz des Modegeschäfts im Straßenraum: Eine kleine Vitrine wurde exakt ins Raster der Steinverkleidung eingepasst; dynamische, zackig geformte Vordächer, die sich in die alten Fenstergewände einfügen, ragen als Blickfang auf den Gehweg.

Subtle interventions on the historical façade draw attention to this fashion store on the street: a small shop window was fitted precisely into the shape of the stonework facing; dynamic, angular-shaped canopies, which merge with the old window frames, dart out in an eye-catching manner onto the pavement.

De subtiles interventions sur la façade historique pour indiquer un peu plus clairement la présence de la boutique de mode : une petite vitrine qui s'enchâsse exactement dans la trame de l'habillage de pierre ; des avant-toits dentelés aux formes dynamiques qui s'encastrent dans l'espace des anciennes fenêtres attirent le regard des passants.

Las intervenciones sutiles en la fachada histórica aumentan la presencia de la tienda de moda en el espacio urbano: Una pequeña vitrina fue ajustada exactamente en la cuadrícula del revestimiento de piedra; los colgadizos dinámicos que se insertan en los antiguos marcos de las ventanas, sobresalen en la acera como punto de atención de las miradas.

164

Weltladen

Atelier Heiss

2003
Lichtensteg 1
1. Bezirk

www.weltlaeden.at
www.atelier-heiss.at

Das Geschäft, das Fair-Trade-Produkte vertreibt, erhielt ein natürliches und schlichtes Ambiente. Möbel aus Raucheiche stehen für Naturnähe, nackte Glühbirnen für Sparsamkeit, denn hohe Baukosten waren zu vermeiden. Durch Entfernen einer Zwischendecke schuf der Architekt dennoch einen großzügigen Raum.

The shop selling Fair Trade products was given a natural and simple ambiance. Furniture made of smoked oak represents nature-conscious lifestyle, exposed light bulbs demonstrate thriftiness, as it was important to avoid high building costs. By removing the interior false ceiling the architect was still able to create a spacious environment.

Pour ce magasin, qui distribue des produits issus du commerce équitable, on a créé une ambiance naturelle et simple. Des meubles en chêne naturel évoquent la nature et des ampoules nues indiquent qu'il faut économiser, en évitant des coûts de construction élevés. L'architecte a cependant réussi à créer un espace dégagé en supprimant les faux plafonds.

El comercio, que distribuye productos de fair trade, recibió un ambiente natural y sencillo. Los muebles de roble ahumado responden de la cercanía con la naturaleza, las bombillas desnudas de la austeridad, pues tuvieron que evitarse costes de construcción altos. Sin embargo, al retirar un techo intermedio el arquitecto creó un espacio amplio.

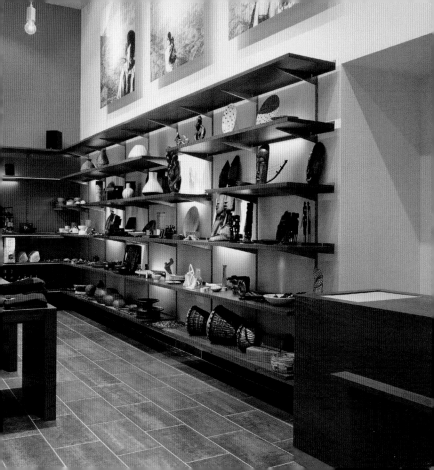

be a good girl

t-hoch-n ARCHITEKTUR

2003
Westbahnstraße 5a
7. Bezirk

www.beagoodgirl.com
www.t-hoch-n.com

Friseur und Modeladen in einem: Alle Einbauelemente basieren auf dem Format DIN A4, Spiegel und Regale etwa sind viermal so hoch wie ein entsprechendes Blatt Papier. Die Warendisplays verlaufen vor der Wand mit 30 Zentimetern Abstand, der Stauraum und Platz für eine indirekte Beleuchtung bietet.

Hairdresser and fashion store in a single unit: all interior furnishings are based on the A4 format, with mirrors and shelves being around four times as large as the corresponding A4 paper version. The merchandise display unit is 12 inches from the wall, leaving space for storage and discreet lighting.

Tout en un, un salon de coiffure et magasin de mode : le format de base de tous les éléments intégrés est le DIN A4, miroirs et étagères sont environ quatre fois plus haut que la feuille de papier de ce format. Les présentoirs sont placés à 30 cm du mur, ce qui laisse un espace pour des rangements et un éclairage indirect.

Peluquería y tienda de modas en una: Todos los elementos montados se basan en el formato DIN A4, por ejemplo los espejos y las estanterías son cuatro veces más altas que la correspondiente hoja de papel. Las exposiciones de productos discurren delante de la pared a 30 centímetros de distancia la cual ofrece lugar para almacenar y espacio para una iluminación indirecta.

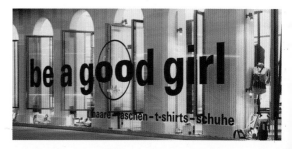

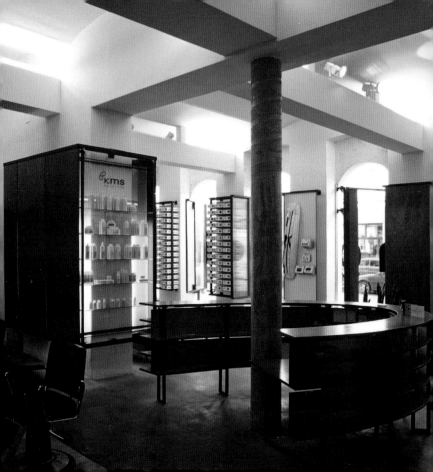

MQ Ticket Center

PPAG Popelka Poduschka Architekten

2003
Museumsplatz 1
7. Bezirk

www.mqw.at
www.ppag.at

Der zentrale Ticketverkauf und Shop fürs MuseumsQuartier fanden in einem barocken Gewölbe Platz, das lila gestrichen wurde. Entlang der Wände zieht sich ein Regalsystem mit Schienen zum Einhängen von Warenträgern, zwischen den Schienen scheinen schallplattengroße runde MQ-Logos dahinzurollen.

The central ticket sales booth and shop for the MuseumQuartier were accommodated in a baroque arched square, which was painted purple. A shelving system lines the walls with tracks for hanging merchandise display units and MQ logos, which are the size of an old long playing record, seem to roll in the spaces between the tracks.

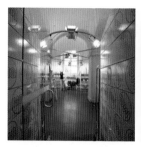

Le centre de vente de billets ainsi que la boutique du Museums-Quartier ont été aménagés dans un espace voûté peint en mauve. Un système d'étagères sur rails pour suspendre les éléments de rangements s'étire le long des murs ; des logos du Museums-Quartier ronds et de la taille d'un disque semblent rouler entre les rails.

La venta central de billetes y la tienda para el barrio de los museos (MuseumsQuartier) encontraron un lugar en una bóveda barroca que fue pintada de lila. A lo largo de las paredes se extiende un sistema de estanterías con carriles para colgar los portantes de los productos, los logos MQ redondos, del grosor de un disco de música, parecen rodar hasta allí entre los carriles.

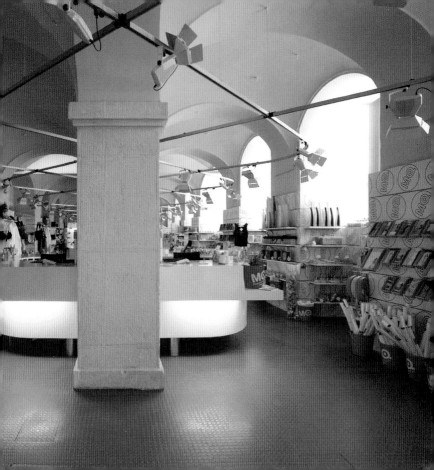

Tiberius
Shop für Fetischbekleidung
Shop for Fetish Clothing

BEHF Architekten

2004
Lindengasse 2a
7. Bezirk

www.tiberius.at
www.behf.at

Ein Fetischladen ohne das übliche Schmuddel-Image, stattdessen mit anspruchsvoller Architektur, die das reizvolle Sortiment in den Vordergrund rückt. Die offene Schaufensterfront gestattet Einblicke, große Einbaumöbel in Weiß gliedern den ganz in Schwarz gehaltenen Raum und schaffen diskrete Zonen.

This fetish store lacks the usual shabby image. Instead, its sophisticated architecture gives center stage to a tempting collection. The open-plan shop window makes it possible to look right into the store. Large, built-in white furniture creates discreet zones in the showroom, which is kept totally black.

Une boutique pour fétichistes qui à la place de l'image douteuse habituelle, profite d'une architecture de qualité qui met en avant l'assortiment plein d'attrait. La bande de baies vitrées qui donnent sur la rue laisse entrer les regards, de grands meubles intégrés blancs structurent la pièce noire et créent ainsi des endroits discrets.

Una tienda fetiche sin la habitual imagen desaliñada, en lugar de ello con una arquitectura exigente que pone el atrayente surtido en un primer plano. El frente del escaparate abierto permite los vistazos, los grandes muebles empotrados en blanco dividen el espacio totalmente en negro y crean zonas discretas.

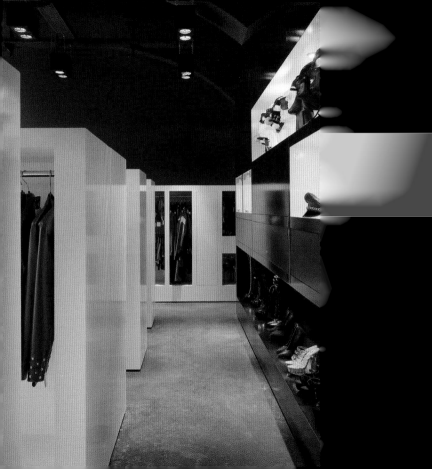

Konzeptstore Park

SPACE + architects

2003
Mondscheingasse 18-20
7. Bezirk

www.spaceplus.at

Der Laden will nicht nur für die Kollektionen junger Modedesigner, sondern auch für Printmedien, Möbeldesign und Kunst eine Plattform bieten. Der weitläufige Raum wurde sehr minimalistisch eingerichtet und ist ganz in neutralem Weiß gehalten. Die Präsentationselemente sind beweglich.

The mission of this store is not only to create a showcase for collections of young fashion designers, but also for print media, furniture design and art. The spacious room was furnished in minimalist style and is kept totally neutral in white. The display elements can be easily moved around.

Le magasin ne veut pas seulement offrir une plate-forme aux collections de jeunes créateurs de mode, mais aussi aux magazines, à la création de mobilier et à l'art. L'aménagement de ce vaste espace est très minimaliste et tout reste dans un blanc neutre. Les présentoirs sont mobiles.

La tienda no quiere ofrecer una plataforma únicamente para las colecciones de jóvenes diseñadores de moda sino también para los medios impresos, el diseño de muebles y el arte. El amplio espacio fue estructurado de forma muy minimalista y es totalmente de color blanco neutral. Los elementos de presentación son móviles.

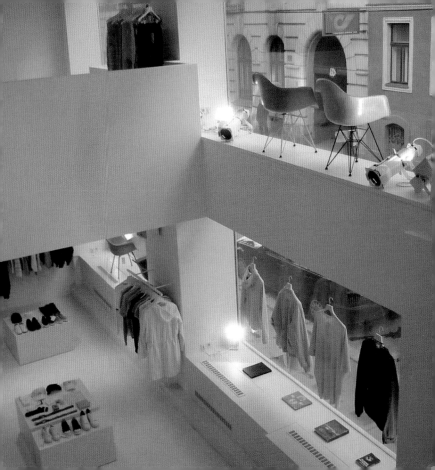

a1 lounge

EOOS

2004
Mariahilfer Straße 60
7. Bezirk

www.mobilkom.com
www.eoos.com

Der Mobilfunkanbieter A1 hat einen Ort geschaffen, an dem Visionen rund ums Thema mobile Kommunikation präsentiert werden. Eine indirekte Beleuchtung an der Kante zwischen Boden und Wand verleiht den Räumen einen leicht surrealen Charakter, Klanginstallationen schaffen jeweils individuelle Stimmungen.

The mobile phone provider A1 has created a space where new visions from the world of mobile communication can be presented. Subtle lighting in the zone between floors and wall gives the space a slightly surreal character, with sound installations creating unique atmospheres in the individual rooms.

Le fabricant de téléphones portables A1 a conçu cet espace pour y présenter ses vues autour du thème de la téléphonie mobile. Un éclairage indirect, installé dans l'angle que forment le sol et les murs, donne aux pièces un caractère un peu surréaliste, des installations sonores créent dans chacune une ambiance individuelle.

El proveedor de teléfonos móviles creó un lugar en el que se presentan las visiones alrededor del tema de la comunicación móvil. Una iluminación indirecta en el borde entre el suelo y la pared dota a las salas de un carácter ligeramente surrealista, las instalaciones de sonido crean ambientes respectivamente individuales.

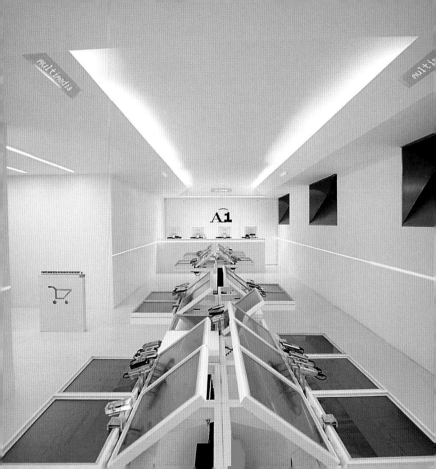

Lexus Center

Atelier Volkmar Burgstaller

2001
Richard-Strauss-Straße 34
23. Bezirk

www.lexus.at
www.burgstaller-arch.at

Eine Wandscheibe durchtrennt das Autohaus, das auf kreisrundem Grundriss errichtet ist, und teilt es in zwei Bereiche: Nebenräume und Verkaufszone. Die nach außen geneigte Fassade wirkt durch ihre rahmenlose Verglasung besonders grazil, ebenso das schlanke, weit ausladende Vordach.

A wall section divides up the car showroom, built to a circular architectural design, to give two distinctive zones: side rooms and a purchasing area. The façade is at a gentle incline towards the outside and looks especially graceful due to its frameless window and an equally slender, but extensive canopy area.

Ce centre automobile, avec son plan en forme de cercle, est partagé par une cloison de verre en deux espaces : la zone de vente et les pièces adjacentes. Les fenêtres, inclinées vers l'extérieur, avec leurs vitres sans châssis, ainsi que l'avant-toit léger qui s'avance largement procurent un caractère élancé et délicat à l'ensemble.

Un disco de pared separa el concesionario que está edificado sobre una planta circular y lo divide en dos recintos: las salas accesorias y una zona de ventas. La fachada inclinada hacia afuera parece especialmente esbelta debido a su acristalamiento sin marco, igualmente el colgadizo delgado y muy amplio.

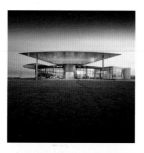

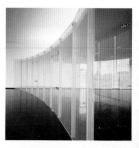

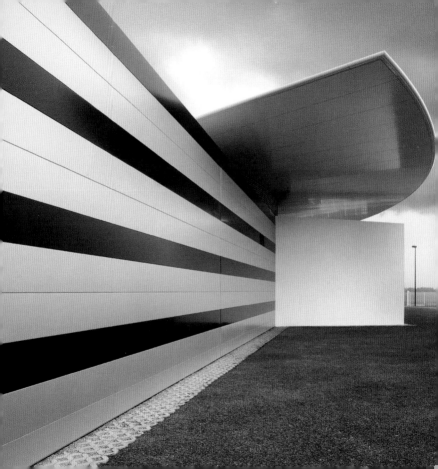

Index Architects / Designers

Index Architects / Designers

Index Structural Engineers

Index Districts

Index Districts

Index Districts

Photo Credits

Photo Credits

Other photographs courtesy

Imprint

Published by teNeues Publishing Group

teNeues Book Division
Kaistraße 18
40221 Düsseldorf, Germany
Phone: 0049-(0)211-99 45 97-0
Fax: 0049-(0)211-99 45 97-40
E-mail: books@teneues.de

teNeues Publishing Company
16 West 22nd Street
New York, N.Y. 10010, USA
Phone: 001-212-627-9090
Fax: 001-212-627-9511

teNeues Publishing UK Ltd.
P.O. Box 402
West Byfleet
KT14 7ZF, UK
Phone: 0044-1932-403 509
Fax: 0044-1932-403 514

Press department: arehn@teneues.de
Phone: 0049-(0)2152-916-202

teNeues France S.A.R.L.
4, rue de Valence
75005 Paris, France
Phone: 0033-1-55 76 62 05
Fax: 0033-1-55 76 64 19

www.teneues.com
ISBN 3-8327-9026-8

Bibliographic information published by Die Deutsche Bibliothek
Die Deutsche Bibliothek lists this publication in the Deutsche Nationalbibliografie;
detailed bibliographic data is available in the Internet at http://dnb.ddb.de

Editorial Project: fusion-publishing GmbH Stuttgart / Los Angeles
Edited by Joachim Fischer; written by Christian Schönwetter
Editorial coordination: Sabina Marreiros
Concept by Martin Nicholas Kunz
Layout: Thomas Hausberg
Imaging & Pre-press: Jan Hausberg
Maps: go4media. – Verlagsbüro, Stuttgart

www.fusion-publishing.com

Translation: SAW Communictions,
Dr. Sabine A. Werner, Mainz
Dr. Suzanne Kirkbright (English)
Béatrice Nicolas-Ducreau (French)
Gemma Correa-Buján (Spanish)

Printed in Italy

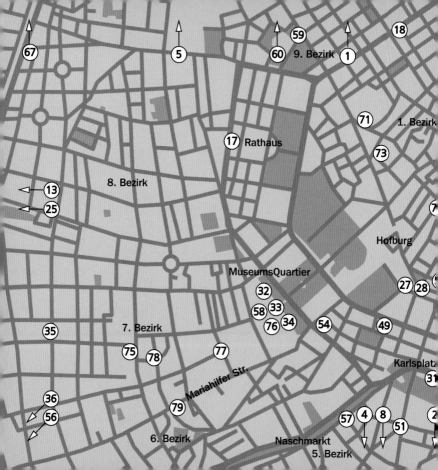

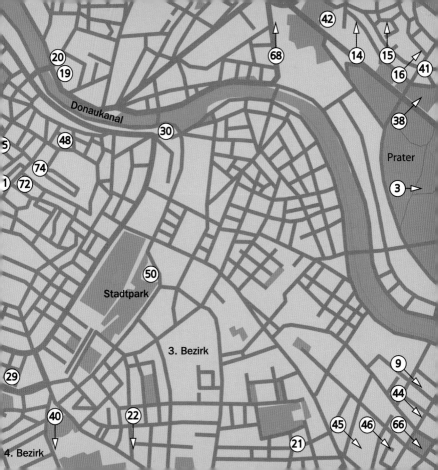

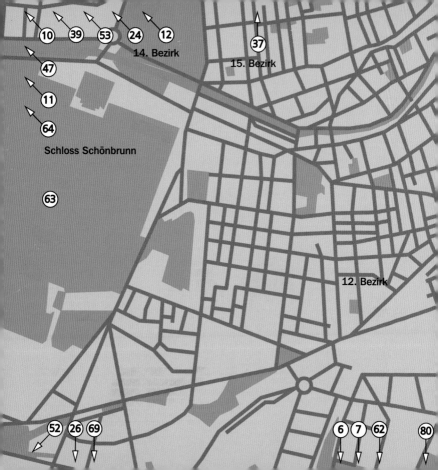

10 **39** **53** **24** **12**

14. Bezirk

37

15. Bezirk

47

11

64

Schloss Schönbrunn

63

12. Bezirk

52 **26** **69**

6 **7** **62**

80